PRAISE FOR
PRESENTATION POWER TOOLS
FOR FINE ARTISTS

"A very practical resource that offers a glimpse of what fellow artists are producing in the way of letters, press releases and other documents, and a great aid in setting up one's own materials." *Constance Smith, Director, ArtNetwork and Author of* **Art Marketing 101**

"It's really terrific! *Presentation Power Tools* is a must for every Fine Art individual who wants to present themselves professionally!" *Linda Handler, Director, Phoenix Gallery, New York, NY*

"The straight-forward instructions, copious samples, and helpful tips in all areas of promotion and publicity make up a systematic approach to achieve professional success. This invaluable information, not taught in schools, helps artists help themselves." *Jen MacDonald, Artist, and Editor,* **Money For Artists**

"This book helped me to win a $10,000 grant! It is the best investment I've made in my career." *Michael Joseph, Artist*

"This book is a great resource for artists. The practical and organized content combined with Renée's experience and enthusiasm is what makes it unique." *Arlene Rakoncay, Executive Director, Chicago Artists' Coalition*

"This book helps artists organize and simplify their lives. Many effective tools are provided that will empower them and tremendously benefit their portfolios." *Susan Schear, Director, Artist Career Planning Services*

"I have never met anyone in the art world like Renée Phillips who is so singularly focused in her pursuit to help artists establish and further their careers." *Edward Rubin, New York Art Critic*

"This book stands out among others of its kind as concise, time-saving and easy to understand. I recommend it to the artists I work with worldwide and use it for my own reference and strategic planning." *Maria Passarelli, Artist's Agent, President, ARC, Fine Art Services*

"Your advice in *Presentation Power Tools For Fine Artists* has given me the courage and knowledge to communicate with the media with great success. You are a pioneer in your work and your services are greatly appreciated." *Sylvana Soligon, Artist*

"The guidelines in this book are concise and clear. This book provides the artist with the tools to take control of their career. It is a must read for professionals and students."*Diane Leon, Artist and Adjunct Assistant Professor of Arts, New York University*

"Renée Phillips truly understands artists, their strengths, their weaknesses, their fears and their needs. Her intelligence, enthusiasm, knowledge and experience of the art world make her a precious resource." *Cali Gorevic, Artist*

"A helpful promotional tool, not only in my negotiations as a fine artist, but it also has great marketing tips for my concert career." *Eoleni Traganas, Painter and Concert Pianist*

"An abundance of valuable information is packed into this book. Renée coaches you on with a spirit of enthusiasm." *Jaye Alison Moscariello, Artist*

"The book is empowering. The expert advice on writing the business letter and promotion materials have given me confidence to approach galleries and collectors." *Alan Levin, Artist*

"This book is indispensable. Thank you for holding a hand out to all of us who are many times discouraged." *Denise Iacovone, Artist and Co-founder, Coalition of Creative Arts (COCA)*

"This book has been of immeasurable help in terms of explaining the business of art. This is my second career and I'm extremely fortunate to be having great success. Thank you for writing with a generosity of spirit, which comes through loud and clear." *Laraine Jablon, Artist*

"Renée is all about helping artists become successful. Her books and her career guidance make the business end more approachable for the artist." *Cornelia Seckel, Publisher, Art Times*

"This book is a wake up call for artists to take control of their careers, and not leave them to chance or the vagaries of the marketplace." *Lynne Friedman, Artist, President, NoHo Gallery*

"When a New York dealer came to my studio to see my work he remarked that I had an excellent presentation packet, which I had assembled by following the advice in *Presentation Power Tools For Fine Artists.*" *Linda Lippa, Artist*

"*Presentation Power Tools* is informative and educational. The examples are very clear and professionally addressed." *Raul Manzano, Artist and former President, Westside Arts Coalition*

"When I was offered a major exhibition and appearances on television and radio this book guided me step-by-step." *Heather Firth, Fine Art Photographer*

REVISED AND EXPANDED THIRD EDITION

SECOND PRINTING 2005

PRESENTATION POWER TOOLS FOR FINE ARTISTS

STEP-BY-STEP WRITING GUIDELINES

PROFESSIONAL ADVICE FROM EXPERTS

A VARIETY OF SAMPLES

INTERNATIONAL

200 East 72 Street, Suite 26L, New York, NY 10021 Tel: 212-472-1660

E-mail: info@ManhattanArts.com Website: www.ManhattanArts.com

REVISED AND EXPANDED THIRD EDITION

PRESENTATION POWER TOOLS
FOR FINE ARTISTS

DISCLAIMER: This book contains a number of sample letters, artist's statements, promotion pieces, press releases and other documents. Unless otherwise noted, the names and facts referred to are entirely fictitious, and any resemblance to actual galleries, museums, artists, curators, directors, exhibitions, and events is entirely coincidental. This book is designed to provide accurate and authoritative information with respect to the subject matter covered. It is sold with the understanding that the publisher is not engaged in rendering legal services. If such advice is required, it is advised that the services of a competent attorney or professional person be sought. While every attempt is made to provide accurate information and verify same, the author or publisher cannot be held accountable for errors or omissions.

Published by Manhattan Arts International, 200 East 72 Street, Suite 26-L, New York, NY 10021

Tel: 212-472-1660 E-mail: info@ManhattanArts.com Website: www.ManhattanArts.com

Manhattan Arts International is the publisher of: *The Complete Guide to New York Art Galleries,* and *Success Now! For Artists: A Motivational Guide For The Artrepreneur™.* It also publishes *The Artrepreneur™ Newsletter* and has an online magazine at www.ManhattanArts.com.

Cover Design by Jade Moede

PRESENTATION POWER TOOLS FOR FINE ARTISTS

ISBN 0-9719881-0-2

Library of Congress Catalog Card Number 97-92865
First Edition: 1997
Second Printing: 1998
Third Printing: 1998
Revised and Expanded Second Edition: 2000
Revised and Expanded Third Edition: 2002
Second Printing: 2003
Third Printing: 2005

Dedicated to every Artist and individual

who contributes to helping Artists

achieve their rightful position in the Artworld…

one of power, freedom, respect and prosperity.

ACKNOWLEDGMENTS

This book's success would not be possible without the countless artists and art enthusiasts, artist's agents and art dealers, who have shared their art and aspirations with me in private career consultations and group workshops. I am enormously grateful to all of the devoted readers of *Manhattan Arts International* magazine and e-zine, our newsletter *The Artrepreneur Newsletter* ™ and to every individual, university and organization who purchased the first two editions of *Presentation Power Tools For Fine Artists* and my other books *The Complete Guide To New York Art Galleries: The Complete Annual Guide,* and *Success Now! For Artists: A Motivational Guide for the Artrepreneur™*.

A special appreciation goes to Paloma Crousillat for her enthusiastic and steadfast editorial assistance. My heartfelt gratitude is extended to Jade Moede, Fine Artist and Graphic Designer, for his outstanding talent and unwavering commitment to designing this book's cover and samples for The Visual Impact section. And, many thanks to Janet Appel, Stephen Beveridge, Frank Bruno, Edward Rubin, John Ross, Cornelia Seckel, and Carole Sorrell for sharing their professional expertise on subjects contained in this book.

The book would not be complete without the Artist / Dealer Agreement supplied by the Chicago Artists' Coalition and wonderful samples of artist's statements, biographies and press releases received from artists, galleries, art institutions and publicists including: Jennifer Bartlet; Gaye Elise Beda; Bernarducci.Meisel.Gallery; Patricia Brown; Leonora Carrington; Mark di Suvero; Kathy Fujii-Oka; Joan Giordano; The Guggenheim Museum; Grant Lindsey; Barbara Mathes Gallery; Richard Mayhew; The Metropolitan Museum of Art; New York Artists Equity Association; Regina Noakes; Olea Nova; Dellamarie Parrilli; Valerie Patterson; Susan Rothenberg; Roslyn Rose; Salander-O'Reilly Galleries; Annie Shaver-Crandell and Steuben.

I wish to thank those who generously provided endorsements for this third edition including: Diane Leon, Artist and Adjunct Professor of Art, NYU; Regina Stewart, Executive Director of New York Artists Equity; Linda Handler, Director of Phoenix Gallery; Constance Smith, Director of ArtNetwork and Author of Art Marketing 101; and Susan Schear, Director of Career Planning Services, and so many others.

And a special thanks to my family and friends, especially my nephews Jason and Michael and my nieces Cheri and Vanessa who are a continuous source of inspiration.

TABLE OF CONTENTS

4. RAISING THE VOLUME ON SELF-PROMOTION

5. PROMOTING YOURSELF WITH A WEBSITE

6. GETTING IT SIGNED, SEALED & DELIVERED

7. RESOURCES

INTRODUCTION

Color is the keyboard, the eyes are the hammers,
the soul is the piano with many strings.
The artist is the hand that plays,
touching one key or another purposively,
to cause vibrations in the soul.
Vasilly Kandinsky

What are Presentation Power Tools?

Business Letters, Biographies, Résumés, Brochures, Artist's Statements, Press Releases, Websites, Newsletters, Testimonial/Comment Sheets, CD-ROMS, Videotapes, Gallery Presentation Materials, Artist / Gallery Agreements, Consignment Agreements, Grant Proposals, Bill of Sale and Invoices. These are some of the tools that help you build a strong presentation in the sale and exhibition of your work. They comprise your career management team. When put into motion they can become your strongest support system and your most assertive sales force. They are the vital instruments that launch and sustain the careers of successful, full-time, self-sufficient artists. This book provides many samples of each along with step-by-step instructions on how to prepare them.

What led to the creation of this book?

For the past 20 years as a private career advisor and coach I have been helping artists develop exactly what the title of this book says – **PRESENTATION POWER TOOLS FOR FINE ARTISTS**. Artists and artists' representatives from all over the world have sought my guidance on a range of career issues, such as clarifying career goals and business plans, procuring patron support, selecting appropriate galleries, developing art markets, increasing income and publicizing exhibitions.

This book was created step-by-step, as I wrote, researched, gathered and organized the important materials that artists need to develop a successful career. In the process I also consulted with various experts in the fields of law, licensing, publicity, marketing, curating and art writing that supplied their sage advise and samples of documents.

This edition is a compilation of some of the best quality materials available. As a member of the International Association of Art Critics and Editor-in-Chief of *Manhattan Arts International*, I receive several hundred packages each week from museums, galleries, universities and artists. The majority of useable press materials arrive from museum personnel, publicity-savvy gallery directors (whose artists are already established) and from public relations firms. My position enables me to share the best samples of presentation materials with those who need it the most.

My career has granted me the privilege of meeting artists of all professional levels, ages and origins, working in all media and styles. They have been full- and part-time artists from a wide range of backgrounds including administrative workers and waiters, holistic and medical practitioners, art students and educators and financial and technology experts. I have counseled extraordinary individuals including an artist who was a Nobel Prize recipient, a renowned plastic surgeon who is a sculptor, one of The Beatles' personal photographers and an artist who is also an inventor.

Regardless of their career experience, all of my clients' goals have required the preparation or polishing of business, promotion and marketing tools. A talented woman left a prosperous career in finance to pursue her passion for painting. I helped her prepare a business plan to acquire patronage. A well-known photographer sought my advice before signing a contract with a leading New York gallery. Our consultation helped him to appreciate the value of his work and prevented him from losing many thousands of dollars. Another artist, who had received scores of positive reviews from critics, was stymied when asked to write an artist's statement for a book. Together we faced her fears, and I coached her in the process of completing her mission.

As a result of helping artists with their documents we have shared many rewarding experiences. Art critics' essays have led directly to sales. Attractive brochures have doubled their income. Powerful business letters have initiated important relationships. Polished presentation books have led to gallery representation and one-person shows. Properly prepared press kits have landed artists on the cover of magazines and newspapers. In addition to sharing this information in private consultations, I incorporate it my seminars. I wanted to share the knowledge with every artist who wants to receive it, so I created the first edition of **PRESENTATION POWER TOOLS FOR FINE ARTISTS** in 1997, the Second Edition was published in 2000, and the Third Edition was published in 2003. Due to great demand this is the third printing of the Third Edition.

Why is this book necessary?

You have only one chance to make a first impression: So make it *powerful!* In your hands these **POWER TOOLS** will help you build a foundation that will lead to freedom and prosperity.

This book gives all artists of all levels the same opportunity to achieve professional success. With the simple, step-by-step instructions and samples, the artist or agent can launch marketing strategies, pursue gallery recommendations, increase sales and income and engage in publicity campaigns, with ease and expertise.

This book helps to reverse the artist's condition from self-sabotage to self-empowerment. Many artists are unaware that their poorly produced documents can disable years of creative effort.

Countless artists from all parts of the globe come to the United States fearful that their inadequate English language skills with lead to rejection. **PRESENTATION POWER TOOLS FOR FINE ARTISTS** strives to remove intimidation and anxiety and replace them with confidence, hope and peace of mind. Self-esteem and quality materials can propel their work to a higher level.

Why should the lack of communication tools prevent an artist from acquiring an exhibition? Why should an artist lose a well-deserved grant because they cannot write a required artist's statement? Why must only a few artists bask in the warm glow of recognition because they have learned how to establish a rapport with the press? Why should an artist be caught without promotion pieces when they meet Mr. or Mrs. Prospective Buyer at a gallery, bus stop, airport or exhibition? This book levels the playing field.

Why do we need Presentation Tools?

In this highly competitive field talent alone does not suffice and art doesn't sell itself. Although many people follow their intuitive responses, and never require the assistance of other individuals or sales materials to buy art, the majority of individuals rely on credentials, experts and supportive materials when it comes to making purchases. And, the more expensive the item the more essential these materials are. Art is a reflection of an individual's taste or the image of a business and requires time and thought. Positive presentation materials reassures buyers that their inclination to buy a particular work of art has been validated by the decisions of others.

We cannot deny that the economy affects buying behavior. Prices soared to dizzying heights in the "80's Boom." Many overzealous art sellers roused unsuspecting art buyers to play in the art market frenzy. Many art buyers got burned. Since the early "90's Bust" many buyers withdrew from the field. Now, in the new millennium we see a new generation of more educated collectors. Like the artists whose work they collect, they want to play more of an active role in the art business process.

There is a growth of direct communication between the artist and the collector, spurred on further by access to artists on the Internet. Today, the artist who practices self-promotion and implements marketing tools through direct mail or from their website can attract and sell to a world of prospective buyers.

The bigger your reputation the more value is accredited to your work and the more influence you gain. Simply stated: if you want to increase your fame and fortune raise the volume on self-promotion. This book leads you through detailed instructions on how to increase your success rate for attracting publicity for yourself, your gallery and your organizations. It also provides step-by-step guidance on how to prepare pitch letters, press releases and press kits. Experts in the field will guide you. Carole Sorrell and John Ross, of Carole Sorrell Incorporated, offer sage advice based on their extensive experience working in the visual arts with museums, galleries, and artists. Janet Appel, President of Janet Appel

Public Relations shares strategies and tips culled from her experiences of generating publicity for her diverse clients. Cornelia Seckel, Publisher of *Art Times,* sheds light on the publicity process, with guidelines on how to develop a relationship with members of the press.

Written materials serve as useful tools on their own, and they enhance your *verbal* communication, as well. An artist's statement, for instance, can help you explain your work to an art writer, dealer or prospective buyer. In our fast-paced society, there are many times you will be faced with little time to make a convincing proposal. The artist who is succinct and persuasive attracts support from others.

Presentation materials are necessary because you don't always have the opportunity to present your original art work to dealers and prospective buyers. You usually make the introduction with slides and other supportive materials, therefore they must reflect the highest level of your creative endeavors.

Are Powerful Presentation Tools costly & time-consuming?

No. Successful self-promotion is governed less by finances and more by creativity, communication, clarity and commitment. The easy-to-follow instructions and variety of documents offered in this book have been designed to save time, money and costly mistakes. I have helped many artists achieve their career goals and increase their income with the aide of simple, low-cost materials. Use the samples as guidelines and shape them into the styles and methods that reflect your individuality. Invent new and interesting ways to make your mark! And, what ever you produce to promote yourself, get them into circulation. The most expensive materials will not help anyone if they are seen by only a few.

Sometimes only a few *minor* adjustments are required. Reorganizing the visual images in a gallery presentation portfolio, rewriting a biography or selecting the best image for an advertisement, gallery invitation or home page of a website can make a *major* difference. For the artist, the tangible results may be a substantial surge in sales or the attention of a more prestigious gallery.

Who should read this book?

Anyone in the Fine Art field who wants to achieve more success in the areas of promotion, sales and publicity. That includes artists and artists' representatives, arts and cultural organizations, directors of commercial galleries as well as alternative, non-profit exhibition venues.

Artists who want to improve their relationships with dealers will benefit from this book. Today, with so many artists competing for the same exhibition venues and visibility, the artists who have business savvy make more attractive partners.

Anyone who wants to protect their valuable assets and have peace of mind. The book contains essential Letters of Agreement, the extensive Artist/Gallery Agreement Checklist and Sample Consignment Agreement, The Bill of Sale, Invoice and other important documents.

Artists who strive for independence will appreciate that I have written this book to motivate them to become more self-sufficient, and enable them to operate successfully *without* a gallery, if they so desire. Susan Schear, President of ArtIsIn states: "This book helps artists organize and simplify their lives with an opportunity to utilize many effective tools provided under one cover. It will empower them and tremendously benefit their portfolios."

The processes of creating and marketing art are often performed in isolation, which can produce feelings of alienation. It is uncomfortable for many artists to take their *private* lives to the *public*. **PRESENTATION POWER TOOLS** provides an inside view into what other artists are doing to advance their careers.

Students of Fine Art must be prepared for the challenges of the business of being an artist. Unfortunately, most art departments lack sufficient education in these areas. For those Fine Art programs that address these needs I hope **PRESENTATION POWER TOOLS** will find its way into their classrooms. Diane Leon, an artist and adjunct assistant professor of art at New York University orders the book for her students. She says, "The guidelines in this book are concise and clear. This book provides the artist with the right tools to take control of their career."

The goal of **PRESENTATION POWER TOOLS** is to empower you with valuable information and tools and to coach you to take action. As your career develops I hope this book grows with you and continues to provide the answers you need. If I have succeeded, this book itself will be a positive tool in your rewarding and joyful journey to success.

Please contact me if you would like to receive personalized guidance and comments on any of the materials you create, or would like assistance with career strategies. I hope to see you at my workshops, book-signings and seminars in the near future. I also look forward to seeing your **PRESENTATION POWER TOOLS!** Please send them to me.

Best wishes for success in all of your creative pursuits!

Renée Phillips

You are cordially invited to visit us at

www.ManhattanArts.com

Our website reflects the mission of Manhattan Arts International

We are A Network of Artrepreneurs™ dedicated to:
- Providing exposure, career guidance, resources and opportunities for artists
- Building relationships among fine art professionals and art enthusiasts

Online Gallery

Featuring the work of more than 350 artists in a range of styles and media. Artist Profiles and Exhibitions. Every year Manhattan Arts International presents the following thematic exhibitions: Small Works; Herstory; Healing Power of Art; and I Love Manhattan.

Artists Resource Listings

Hundreds of opportunities and resources including international and national juried exhibitions, grants, residencies, periodicals, books, websites, and professional services.

ManhattanArts International online Magazine

Dozens of articles and interviews on the subjects of Art & Business and Art & Life.

www.ManhattanArts.com

LAYING THE FOUNDATION FOR SUCCESS

We act as though comfort and luxury were the chief requirements of life,
when all that we need to make us happy is something to be enthusiastic about.

Charles Kingsley

TAKING CARE OF BUSINESS

Whether you are in the beginning stages or at the top of your career, taking care of business means protecting your valuable assets. Taking care of business does not mean you have to sacrifice your creativity or the integrity of your work. Professional advancement is acquired through learning how to balance the freedom of artistic expression with pragmatic planning and action.

During most of your career you will be in the position of having to be your own marketing and promotion director in addition to being an artist. Your professional career will be divided into three roles: one-third as a creator; one-third marketer and promoter, dealing with getting the clients; one-third as an administrator, taking care of the necessary paper work, telephone calls, mailing, etc. Naturally, these three essential roles will not always be equally divided at the same time. You will define your own schedule and work according to other demands and degrees of success. Once you find effective ways to handle the marketing, promotion and administrative work, you will gain the rich reward of more time for creativity.

Learn to delegate as much of the tedious, unpleasant tasks as possible to others who can do it more efficiently. Recruit volunteers from your family and friends, artists' groups, senior citizen centers, the local schools and your neighborhood. Hire skilled professionals when the task requires it and the budget

permits it. Also learn how to roll up your sleeves and get things done. Once you incorporate the necessary tasks into your daily routine, the rewards will be worth the effort, and your feeling of boredom and resentment will be replaced with pride.

In maintaining your business as an artist, good record keeping is vital because the first step in planning a prosperous and productive future is to study and reflect upon what you have done in the past. Your business expenses, projected income, profits and losses, failures and successes, slow and immediate results, all need to be scrutinized and evaluated in detail.

Taking care of business means planning for success. Many artists neglect the importance of planning for an exhibition and wait until the exhibition opens before they think about selling. The truth is the marketing activities should begin the day the date is set in writing. The planning stages begin by marking all essential activities and deadlines on your calendar. It is far better to have one less work framed than to neglect crucial time cultivating the attendance and motivating interest in your show. Full-time, self-supporting artists know marketing is a 365-day a year activity.

Taking care of business requires having the necessary nuts and bolts to keep your accomplishments at top speed. Establish your business in the best form will fit your needs such as: proprietorship, corporation, partnership, limited partnership, non-profit corporation

Here are some of the business tools you can utilize to setup your business:

Business Name	Business License	Checking Account
Receipt forms	Sales Tax Permit	Insurance
Telephone	Answering Machine	Fax machine
E-mail address	Website	Computer
Rolodex® file	Filofax ® organizer	Appointment book
Database Program	PDA (personal digital assistant)	Palm Pilot
File folders and file cabinet	Letterhead	Logo
Envelopes	Postage	Shipping Boxes
Packing Tape	Calendar	Pens
Pencil Sharpener	Art Resource books	Digital camera
Subscriptions to art and business magazines		

When nothing seems to help, I go and look at a stonecutter hammering away at his rock perhaps a hundred times without so much as a crack showing in it. Yet at the hundred and first blow it will split in two, and I know it was not that blow that did it but all that had gone before.

Jacob Riis

PLANNING YOUR GOALS & STRATEGIES

He who controls others may be powerful,
but he who has mastered himself is mightier still.
Lao Tsu

Power comes from knowing who you are and what your purpose is. Joseph Campbell encouraged us to "Follow your bliss." Socrates advised: "Know thyself." Lao Tsu revealed: "He who controls others may be powerful, but he who has mastered himself is mightier still."

It has been said that winners are "ordinary people, doing ordinary things, extraordinarily well." When you watch the Olympics, you might notice the Gold and Silver medal winners are not necessarily more talented, younger, stronger or richer. Often the difference between the winners and the others is a tiny difference, perhaps an instant of lost concentration.

As an artist you certainly don't have the stressful physical challenges of an athlete, but you are nonetheless engaged in a competitive field. The difference between one artist who makes his or her mark and another who does not is not necessarily the degree of technical prowess, education, creative vision or luck. It is more about the measure of their intensity of desire, commitment and focus. It is also how they formulate their goals and persevere, accomplishing monthly, weekly, daily and hourly goals. Successful artists and all *artrepreneurs*™ see the big picture while never losing sight of the significant details.

As a consultant and coach helping artists advance their careers, I have observed the tiny differences between artists who succeed at accomplishing their goals and those who fail. I have learned the power of beginning a consultation by giving them a "Pre-consultation Questionnaire" which includes, "What are your priorities?" "Where do you want to be one or two years from now?" This exercise is often the first opportunity they have to step back and define their objectives. It enables them to take charge of their careers rather then leaving their outcome to chance.

My purpose is to insure that my clients examine their career achievements and their priorities, and give themselves a chance to explore their dreams and envision their unlimited potential. By starting the process in this manner, an opportunity is presented for the client to seriously think about their life's purpose. A consultation may concentrate primarily on the nature of the career objectives themselves, with the goal being to bring to them a sense of harmony and balance with their personal values and goals. From there, it is easier to provide realistic career strategies, leads and resources to accomplish their goals. If this first step is not crystallized there will be increased occurrences of confusion, indecision and doubt.

This process leads to more questions such as: What are your *passions*? What *kind* of artist do you want to be? What do you want to *do* with your art? We also reflect upon the various career choices and paths they have taken that have brought them to their present situation.

Since most of the artists who seek my guidance are introduced to me through my book *The Complete Guide to New York Art Galleries* they often express their goal as finding a New York gallery. This goal, although sincere, requires strategies and activities. A sample of how we might face this challenge might be: To develop a body of work that would be marketable in a gallery; to seek gallery sources that would be appropriate for my work; to prepare a professional presentation book to show to galleries.

Nothing happens unless first a dream.
Carl Sandburg

As your true passions unfold you can envision your artistic, career and financial goals. Once you develop strategies you can focus on developing daily activities that will transform your life's mission step-by-step. As you accomplish these activities your life grows with an inner strength and purpose.

Visualize your dreams. Imagine yourself there. Contemplate the thrills you will experience when you reach it. For example, let's say you want to have a large studio. How will you feel when you have it? What will you do in it? Find pictures of the studio of your dreams in magazines and paste a picture of yourself in it. Place it where you will see it daily. Let the desire ignite your steps to take action.

If the fear of failure is preventing you from making a sincere effort, remember one thing all successful people have in common is that they have all tried and failed many times along the road to success. Similar to an Olympic champion, it requires building one muscle or honing one skill at a time. Charles Darwin said: "It is not the strongest of the species that survive, nor the most intelligent, but the one most responsive to change." Julia Soul said: "If you are never scared, embarrassed or hurt, it means you never take chances." Create new goal plans periodically, and set higher ones with each triumph. Be flexible. When one plan doesn't work, try another!

In writing your goals, be specific. It is not sufficient to say: "I want fame and fortune." How do you define fame – in what context and in what numbers? What will you do to acquire that fame? How much fortune is sufficient for the kind of lifestyle you desire? What will you to do with your fortune? When (specific date) will you reach your financial goal (specific dollar amount)? How will acquiring these goals affect other areas of your life? Will you use the money to improve your family's lifestyle? Increase your travel to other countries? Open an art school? What compromises and changes must you make? Continue to ask questions.

An example of a *desire* might be to move from a small studio apartment to a two-bedroom apartment with a separate studio. The **goal** might be to earn $50,000 this year from sales of your artwork. A *strategy* might be to increase sales through galleries. **Activities** might be to create a presentation kit to send to galleries, purchasing a mailing list, researching appropriate galleries, hiring an art photographer, revising your résumé and artist's statement and networking with artists who are represented by galleries. Write these activities on paper and develop a **Daily** schedule. Make a commitment to stick to it.

Follow your bliss.

Joseph Campbell

SAMPLES OF GOALS, STRATEGIES & ACTIVITIES

Desire/Goal: To be financially self-sufficient and provide a better lifestyle for my family.
Increase sales from $15,000 to $50,000 annually.

Strategy: Develop working relationships with several corporate art consultants and art buyers.

Activities: Prepare brochure for mailing. Get estimates from at least three different printers.
Obtain list of corporate art consultants from Manhattan Arts International.
Attend events where art buyers go, then socialize and hand out my brochures.

Desire/Goal: Use my art as a catalyst for healing in hospices, hospitals and orphanages.

Strategy: Become an active, recognized member in the Arts and Healing community.

Activities: Join the Art and Healing Network and volunteer for the Events Committee.
Link my website to other Art and Healing websites.
Produce a press kit with my mission statement, visuals and testimonials from
members of the healthcare field and send it to appropriate members of the press.

Desire/Goal: Unify people of different cultures though the power of my art.

Strategy: Create large sculptures that express the feeling of Peace and Harmony and place them in public venues throughout the world.

Activities: Locate a large studio and foundry to execute my ideas.
Research travel grants at The Foundation Center at www.fdncenter.org.
Explore local embassies for opportunities to exhibit my work.
Contact the Art in Embassies Program.

Desire/Goal: Become an active artist's advocate.

Strategy: Gain the support of influential members of the art, political and business community.

Activities: Join New York Artists Equity Association and work on a committee.

Join the Chamber of Commerce and develop an arts program.

Organize panel discussions among members of the art and business communities.

GOALS, STRATEGIES & ACTIVITIES WORK FORM

Desire/Goal: _Increase sales + pricing_
Set up Business including inventory, website, database

Strategy: _____

Activities: _____

Desire/Goal: _____

Strategy: _____

Activities: _____

Desire/Goal: _____

Strategy: _____

Activities: _____

Desire/Goal: _____

Strategy: _____

Activities: _____

QUICK TIPS

- Develop separate Creative, Career and Financial goals that bring balance to your life.
- Prioritize your daily "To Do" list and place your top three goals into time slots.
- Consider your list as a commitment – like unbreakable appointments with yourself.
- Try your best to do your top first goal early in the day.
- Always expect a task to take twice as long as you anticipate.
- Allow for interruptions and surprises that come with each day and that are beyond your control.

Know thyself. Socrates

QUESTIONS
THAT HELP YOU REACH YOUR GOALS

The best way to find your path to success is to ask questions like these:
- What do I want to achieve in my life?
- What are my priorities today? This year?
- What small step can I take today that could enhance my career?
- When do I procrastinate and why?
- Am I currently creating the kind of art that my heart desires?
- What toxic relationship should I terminate?
- How am I sabotaging my career?
- How much money do I want to earn from my art this year?
- How can I channel my talent to serve humanity?
- What do I want people to say at my eulogy?
- Which new medium or technology do I want to explore or, better yet, invent?
- What should I be teaching others about myself as an artist and about art and artists?
- How do I describe myself?

 a. I am a self-starter, focused and disciplined, and don't need motivation from others in order to attain my goals.

 b. I accomplish the most when I have deadlines with the help of a coach or a team.

 c. I don't set goals. I avoid paying attention to time management.
- How would I like to earn my living?

 a. Sales of my work as a full-time artist.

 b. Sales of my art combined with another source of income.

 c. Income from a non-art job so I don't have to be concerned about sales of my artwork.

- How much time each week do I devote to actively promoting and marketing my work?

 a. Less than 5 hours.

 b. 5-10 hours.

 c. More than 10 hours.

- How do I assess my education of art and the business of art?

 a. My education is adequate in both areas.

 b. I need to acquire more knowledge in art history and technique.

 c. I need to acquire more knowledge in the business of art.

- How do I describe the condition of my studio?

 a. I have a separate studio space where I can create art without being disturbed.

 b. My work area is a separate space but is too small to create the kind of art I desire.

 c. My work area is part of my living space and inhibits productivity.

- How much do I socialize in order to further my career?

 a. I regularly attend gallery receptions, art and business workshops, and other types of events where I meet new people and exchange business cards.

 b. I attend some events but I leave without ever making a new business acquaintance.

 c. I'm not a people-person.

- Which best describes my presentation materials?

 a. Several slides/photographs/CD or brochure, an up to date résumé or biography and artist's statement. My materials are neatly arranged in a binder or folder.

 b. Slides of some of my work and/or a few photographs and a résumé, but it's not up to date.

 c. None of the above.

- Which best describes my current body of work?

 a. At least 10 different pieces created with a distinctive style and in the same medium.

 b. Some pieces with a distinctive style and different medium.

 c. Many different pieces – I'm not sure what direction to go in.

- Where do prospective customers see my work?

 a. My work gets continuous exposure in at least four of these outlets: fairs, juried shows, galleries, advertisements, on the Internet and in Open Studio events.

 b. My work is on view sporadically, a few times a year.

 c. I hardly ever show my work.

- How much do I know about my prospective buyers?

 a. I know a lot about their level of appreciation of art, lifestyle and spending habits.

 b. I have limited knowledge about who would be interested in my work.

 c. I never gave it any thought.

- Do I have a marketing plan?

 a. The only time I think about sales seriously is when I have an exhibition.

 b. I know I should spend more time and effort but my motivation dissipates quickly.

 c. I have a marketing plan and spend time cultivating clients on a steady basis.

More than 90% of the artists Manhattan Arts International surveyed share the goal of wanting to be full-time artists, supporting themselves with sales of their work. However, 80% of them spend less than 5 hours a week actively promoting and marketing their work. What's wrong with this picture?

STRETCHING TIME & SPACE

Creation begins with a vision.
Hénri Matisse

Time often appears as our rival in the game of life, in our challenge to capture and control it, get ahead of it and make the most use of it. We try to juggle several balls in the air at the same time – the responsibilities of raising children, caring for an elderly parent, holding down a job and our need to replenish ourselves with creativity. It is no wonder that stress is so prevalent, with a plethora of pills and homeopathic remedies that promise to cure. We need help!

Creativity has its own force that often refuses to abide by logic, organization and discipline. However, we must also learn to employ cognitive time management tools if we want to increase our harmonious space for creativity and decrease the stress that normal living can produce.

QUICK TIPS

- Be committed to the project. Organize the task and set aside sufficient time without any distractions. Rehearse the task mentally. Quiet the mind. Focus your attention. Take each step deliberately. Become totally absorbed in what you're doing, and a free-flowing momentum will transpire. You will get the job done faster and easier.
- Manage your business space by creating a separate work area. If possible, use a separate room for an office. If space is limited, at least arrange a space in a corner of your studio or bedroom or even a closet. Keep materials organized and easy to locate. In your work area place your phone, rolodex, appointment book and a file cabinet to store your photographs, slide sheets, résumé and business receipts. Keep this area free from visual and sound distractions that may interfere with your concentration. Eliminate clutter.
- Use computers and other technology to improve efficiency. Also create and use lists, calendars and appointment books, manila folders, filing cabinets, index cards and other time-saving organizational methods. Alphabetize your files and organize your materials to help you locate them quickly. Buy and/or create such materials that are colorful, well designed and aesthetically appealing to you in order to make working with them a creative experience.
- Set time aside each day and/or week to work on your career. Ideally, this should be a peak energy time when you have the ability to focus and concentrate on details.

- Keep a closed door to your private studio. This should be your sacred space, with times when you should let others know that you want to be left alone. You should also provide time to brainstorm, daydream and to restore balance. Set limits on your social life and your family commitments. About the artist's need to build a structure Joseph Campbell said:

"To nurture your creative aspect, you must put a hermetically sealed retort, so that there is no intrusion, around a certain number of hours each day… and that time must be inviolate."

- Be prepared. Make tomorrow's plans and write your "To Do" list the night before and arrange the activities in order of urgency. Create promotional materials by the dozens and have several sets of slides on file. Keep several copies of your current résumé ready to go. Maintain your mailing list on the computer and keep it up to date.
- Subdivide projects. We often set important projects aside while we wait for that big block of time to be available. Chances are it will never arrive. It is better to tackle the larger projects in several small blocks of time.
- Be conscious of how you waste time. Culprits include telephone socializing during work time, a poorly organized work area, procrastination, poorly planned procedures, failure to set priorities, over-commitment and striving for perfection. Do you wonder where time flies? Keep a time log for a week. You'll be amazed at how much time you waste.
- Ask for help. We all have different skills and talents and it is essential to learn to depend on others for assistance. Delegate and share tasks. Recruit high school or college interns to stretch canvases, arrange appointments, make deliveries, send faxes, make trips to the post office and type letters. Invite friends over for an envelope stuffing party accompanied by a good bottle of wine and classical music. Join an art organization in which fellow artists share career development activities.
- Be adept at slowing time. Be mindful of the way you pay attention to the small miracles. Reconnect with a sense of discovery and try to see events unfold through the eyes of a child, watching the first sunrise, or the miraculous way birds fly together in formations. Learn to meditate in your own way. This tip alone will reduce your stress level and help you become more productive.
- Eliminate bad habits. Dismiss all the irritations, the daily frustrations and predictable annoyances of your life once and for all! When you come across an integral problem, don't just fix it for now, get to the root of it and re-design your behavior.
- Maintain good health. You cannot ignore the correlation between good nutrition, mental and spiritual health. When your health is impaired, the future of your career will be threatened. Exercise regularly. Avoid toxic materials, toxic environments and toxic relationships. You may frequently be tempted to work long and hard in your studio and neglect your nutritional needs. Have plenty of fresh foods and clean drinking water close at hand.

MASTERING YOUR MAILING LIST

*Some are born great, some achieve greatness,
and some hire public relations officers.*
Daniel J. Boorstin

Your business success relies upon who you know, and more importantly who knows you – and the more the better. An artist can rise to fame or fall to anonymity depending upon the individuals or patrons who follow his or her work. Suffice it to say, you need to get your message and images out to others on a continuous basis. Persistence and patience will reward you in time.

As your career grows and as your network widens you will build and edit your mailing list. It will begin with your friends, relatives, neighbors, fellow artists, instructors, and everyone who has ever expressed an interest in your work. As you increase your exhibitions, professional activities, and sales it will be augmented by art gallery owners and directors, private dealers, members of the press, individual and corporate collectors, museum directors, curators, corporate art consultants, slide registries, foundations, residencies, and other arts professional associates. You will find leads in publications, resource directories, on the Internet, and through mailing list companies.

QUICK TIPS

- If you are conducting a general promotional mailing, send them out systematically. In order to manage the responses, follow-up calls and letters. Record the materials you mailed, to whom and the date.
- Keep your mailing list up-to-date. Since people move and forwarding orders expire, do at least three mailings each year to "clean" your list.
- If you plan to do regular mailings to members of the press, you may want to enclose a self-addressed, postage-paid response postcard. *(See the section on Raising The Volume on Self-Promotion.)*
- Follow-up with a phone call after mailing. Publicity professionals usually call *before* they send the materials and *after* to make more of an impact.
- Computers provide the most efficient way of storing your mailing lists. There are software programs specifically designed for arranging data and generating labels such as ACT! or Microsoft Office's Excel and Access.

- Record your progress with your relationships on a computer or index cards. File the cards behind the next week or month when you want to contact them again, or make a note in your appointment book to do so. *(Sample cards for maintaining your mailing list are shown below.)*
- For easy access keep your list in alphabetical order and separate them under different categories such as "Collectors", "The Press", and "Dealers."
- Write important information in your appointment book to remind yourself to mail materials. For example, to a gallery that says "Not interested now, but please contact us again in six months with slides of your new work."
- File them away in order of priority as to when you must follow up. Refer to your list and appointment book regularly.

SAMPLE CARDS FOR MAINTAINING YOUR MAILING LIST

COLLECTOR

Name: Georgette Bloom
Address: 8910 Feather Leaf Lane, New Brunswick, VT 00000
Telephone: work 123-456-7890 home 123-456-9876
E-mail: gbloom@earth.com

NOTES
Profession: Real Estate Agent. We met at P.T.A.
Hobby: Golf.
Personal Info: Husband Jim. Daughter Elyse, 10. Diana's classmate.

STATUS
3/1 She bought Season Delight $3,500 at Gallery A.
5/2 I mailed an invitation to my exhibition at Gallery B.
6/11 I mailed her a note with newspaper article about my work.
7/10 She called to arrange a studio visit.

DEALER

Name: Janet Lindenman, Color Field Gallery
Address: 123 Fourth Ave., New York, NY 10000
Telephone: 555-8972
Fax: 555-87323 E-mail: jl@colorfield.com
Website: www.colorfield.com

NOTES
Referred by Alyce Kramer, an artist represented by the gallery.
Yale graduate. Married with two children, 6 and 10.

STATUS
10/2 I mailed a slide package including: slides #1-16 from new Spring Series
10/13 She called and is interested in my work. She is planning group exhibition in April. We arranged a studio appointment for 10/26.

WRITING IT RIGHT

If writing must be a precise form of communication,
it should be treated like a precision instrument.
It should be sharpened and it should not be used carelessly.
Theodore M. Bernstein

Artists have been unnecessarily stymied when called upon to prepare written documents. Their chances to gain exhibition venues, financial support and publicity have depended upon the challenging task of putting pen to paper. Many artists I know have abandoned many projects because of the fear of appearing illiterate or unprofessional.

With this book in hand, the pain and suffering you may have endured will now come to an end! This section of the book will aid you in the preparation of text of all kinds – from business letters to galleries and members of the press to résumés and biographies, and from exhibition and grant proposals to artist's statements and artist's newsletters. The samples can be followed with confidence because they are actual prototypes of letters we have received from leading professional sources. Of course, since your situations and writing style will vary, feel free to add, subtract and shape them to suit your needs.

THE BUSINESS LETTER

Throughout your career the business letter will play an important role. It is a form of written communication to a gallery owner, art consultant, grant-giver, curator, collector or a member of the press. There are different types of business letters, each providing a purpose. Whether the business letter

is a document that stands alone, or is one of several documents in a package, it must be treated with careful attention because it is one of the first items in the package that is read and creates the first impression. The tone of the letter, from beginning to end, should be professional, positive and persuasive.

Your letter should arouse the receiver's interest and inspire their desire to see your work, buy your work, attend your event, contact you, meet you, write about you, grant your request.

TYPES OF BUSINESS LETTERS

- **A query letter** is written to obtain information or make an appointment.
- **A cover letter** accompanies other documents and explains their purpose.
- **A pitch letter** is sent to a member of the press to encourage coverage.
- **An exhibition proposal letter** is offered to procure a show.
- **A follow-up letter** precedes a phone conversation, meeting, sale, event or review.
- **A letter of agreement** can establish and bind a working relationship.
- **An artist's newsletter** keeps your buyers informed.

QUICK TIPS

- Use good quality letterhead that matches your résumé/biography.
- Keep the length to one page, consisting of a few paragraphs.
- Type it neatly and check for accuracy, grammatical and typographical errors. If your computer software is equipped with spelling and grammar checking tools use them.
- Obtain the name, correct spelling and gender of the person in charge and mail the material directly to him or her.
- Send the original copy and make a copy for your records.
- Emphasize the assets or conditions you know to be of importance to the receiver.
- Write in a succinct, professional, positive and persuasive manner.
- Before you begin focus on what kinds of results you want to achieve.
- Send it with an S.A.S.E. (self-addressed, stamped envelope) if you want the materials returned.
- Sign your name above your typed name.

WRITING TO
A DEALER OR ART CONSULTANT

Writing is easy. All you have to do is stare at a blank sheet of paper
until drops of blood form on your forehead.
Gene Fowler

Don't let writer's block rob you from acquiring exhibitions and sales. You can easily achieve the art of writing an effective letter. In an interview in our online magazine, www.ManhattanArts.com, David Rubin, Curator of Visual Arts, The Contemporary Arts Center, New Orleans advised: "The cover letter should be very straightforward such as: 'I am writing to introduce my work to you in the hopes that you may be able to exhibit my work.' It's nothing fancy." He's right: Keep your letters concise and to the point. Follow these quick tips and the samples provided, then watch your opportunities grow!

QUICK TIPS

- Introduce yourself and state why you are sending the materials, such as: I am an artist who is interested in exhibiting my work in your gallery.
- Remind the recipient if you have already met.
- State it if you have been referred to them by a mutual friend or associate.
- Express your level of interest in working with them and why your work is suitable for them.
- Briefly explain what your work is about – scale, medium, subject matter.
- Don't be shy. Mention your strongest achievement(s) and/or future project(s). Consider the needs of the recipient and make sure your letter addresses them. A director of a museum or alternative exhibition space may be interested in the historical significance of your work. A corporate art consultant may be more interested in your commissioned work and prices.
- Be honest, concise and brief. The letter should encourage the recipient to set it aside quickly and get to the materials or see your work.
- List the items that are enclosed.
- Remember that the purpose of the letter is to lead to a direct response. Indicate the type of response you are expecting. Offer to send more materials if needed.
- If you want some or all of the materials returned, enclose a S.A.S.E.
- Send additional materials that they can keep on file.

SAMPLE OF A QUERY/COVER LETTER TO AN ART GALLERY

Barbara Jones
123 Fourth Avenue, Bellmont, VT 00000 Telephone: 111-222-3456

Date

Joseph Black, Director
Black Gallery
Address
City, State, Zip

Dear Mr. Black:

Identify yourself and state the purpose of your correspondence.
I am a painter and am writing to acquaint you with my work. Alexandra Shaw, from Manhattan Arts International, referred me to you. She suggested that my work would be appropriate for your gallery.

Write a brief description of your work. Include a short, positive, professional overview.
My paintings and drawings explore the domain of the mythical and natural world. Most often the paintings are landscapes and gardens. All of my work is derived from photographs that I take on location in my world travels.

I have had group exhibitions at the XYZ College Gallery, Bridgewater, NJ, and the Cornball Cultural Center, NH. My work is included in the Blue Company, in Hud, CA and several other corporate collections in addition to private collections.

List the items you have enclosed. Use bulleted listings if you are enclosing several items.
Please find enclosed the following items:
- Color brochure with my résumé and artist's statement, which you may keep.
- Copies of recent reviews from *The Art Times* and *Contemporary Art Magazine.*
- A sheet of 20 slides and a S.A.S.E. for their return when you are finished reviewing them.

Express your willingness to send more materials or meet in person.
If you find my work of interest, I would be pleased to send additional materials, or bring work to your (gallery) (office) unless you prefer to come to my studio.

Thank you for your consideration. I look forward to hearing from you soon.

Sincerely,

Barbara Jones

SAMPLE OF A LETTER TO AN ART CONSULTANT

Barbara Jones
123 Fourth Avenue, Bellmont, VT 00000 Telephone: 111-222-3456

Date

Robert Fox
Fox Art Advisory Services
123 Deer Lane
Mountainpeak, CA 00000

Dear Mr. Fox:

I am writing to introduce myself as an artist and to express an interest in working with you in marketing my current pastel drawings and prints to your clients.

Write a brief description of your work. Include a short, positive, professional overview.
State your reason why your work is appropriate for this market.
Describe sales history and price range.
My pastel drawings incorporate geometric abstractions inspired by 20^{th} century and futuristic architecture. They have been purchased for the reception areas and lobbies of several businesses in the Santa Valley area, including Builders Plus and Reblin, Inc.

The retail prices of my works range from $350 to $3,250. The sizes range from 12" x 16" to 36" x 48". I often create larger sized paintings and murals to meet the special needs of the client.

Offer to show samples.
Please come to my studio to see the work, or if it is more convenient for you I would be happy to bring original pieces for your review in your (gallery) (office), anytime. My work is also on view at www.ManhattanArts.com/profiles/BarbaraJones.htm

List the items enclosed.
Enclosed for your perusal are six color laser prints of my pastel drawings, 10 slides, my résumé and a current list of corporations that own my work.

Thank you for your consideration. I would welcome the opportunity to discuss whether my work would be appropriate for your client market. I look forward to a favorable reply.

Sincerely,

Barbara Jones

SAMPLE OF A FOLLOW-UP LETTER AFTER A MEETING

Follow-up letters are essential to initiating your relationships as well as solidifying them.

<div align="center">

Barbara Jones

123 Fourth Avenue, Bellmont, VT 00000 Telephone: 111-222-3456

</div>

Date

Elinore Gatchet, Director
Sunflower Gallery
Impressionist Lane
Paris, 00000 France

Dear Ms. Gatchet:

Thank the recipient and remind him/her of your initial acquaintance and reason for following up.
I enjoyed meeting you in your gallery in January and appreciate the time you spent reviewing my slides. At that time you said you would consider my work for your upcoming "Metamorphosis" exhibition in the Fall. As you requested, I am sending you transparencies of six of my recent works.

List the items enclosed.
Remind the recipient of the value and appropriateness of your work to them.
I have enclosed six 4" x 5" transparencies of my most recent paintings, along with a revised artist's statement and résumé. As you can see the focus of my work has continued to be about the weathering process of man-made materials. I have recently added recycled materials to my works. These elements intensify my message about the regenerative powers of nature.

Mention recent accomplishments.
Since January I had a successful exhibition at the Bridge Gallery in Toronto, Canada in which seven of my paintings were sold. One of the paintings was placed in the Airtight Collection, in Cutting, CA.

Encourage a response.
Thank you again for your interest and consideration. I look forward to hearing from you in the near future. I hope you will be able to come to my studio in June to see these new works. Before I leave for my next trip to Paris I will call you to arrange another appointment.

Sincerely,

Barbara Jones

SAMPLE OF A FOLLOW-UP LETTER AFTER A MEETING

Although this letter does not replace a contract it establishes communication and clarifies details discussed verbally. It establishes a solid foundation from which to build. See the artist/gallery checklist, sample contract and consignment agreement in the Signed, Sealed and Delivered section of this book.

Barbara Jones
123 Fourth Avenue, Bellmont, VT 00000 Telephone: 111-222-3456

Date

Barbara Kane, Director
Kane Fine Art
123 Candy Lane
New Bridge, AK 00000

Dear Mrs. Kane:

It was a pleasure to meet you on Tuesday. Thank you for inviting me to participate in your group exhibition "Body Work" in October 2006. As you requested, I am enclosing my updated résumé and a slide sheet representing 20 of my most recent sculptures.

We discussed many topics in our meeting. I would like to be certain that I fully understand the conditions of our agreement. Please confirm this understanding in writing for my records.

- I will be one of five artists and the only sculptor in the exhibition.
- The sales commission to the gallery is 50% on all sculptures in the exhibition.
- The gallery will be responsible for insuring all of the works while they are in the gallery, from October 1-30, 2006.
- I will be responsible for supplying the bases for the 5 sculptures in the exhibition.
- The gallery will, at its own expense, print and mail 2,000 invitations to the show.
- I will not be responsible for any expenditure, except for any advertising and promotion that I may decide to do on my own.
- Your payment policy to the artist is 30 days after you receive payment from the buyer.

Please call me anytime to discuss or confirm these terms and the selection of the pieces for the exhibition. I look forward to speaking to you soon.

Sincerely,

Barbara Jones

SAMPLE OF A FOLLOW-UP LETTER AFTER A SALE

Barbara Jones
123 Fourth Avenue, Bellmont, VT 00000 Telephone: 111-222-3456

Date

Renée Phillips
200 East 72 Street, Suite 26-L
New York, NY 10021

Dear Ms. Phillips,

I want to thank you again for attending my Open Studio party in July and for your purchase of "Treasured Moments." I'm sure you will be delighted to learn that in the last three months the edition has completely sold out. As a result, the remaining few prints increased in value by 25% above your purchase price.

Since you asked me to keep you abreast of my activities therefore, I am enclosing some materials that will bring you up to date. They include:

- A review of my exhibition at Gull Gallery, by Thomas Lawrence, in *The Manhattan Arts Annual.*
- Photographs of three of my new paintings.
- A special pre-publication price list for the new prints. The edition is limited to 200 prints. These prices will be in effect through December 2005.

Please let me know if you are interested in receiving any additional information about the paintings and prints. I can be reached in my studio Tues.-Sat. 10-5. If any of the prints are of interest to you, I would be delighted to send you a proof to examine.

I look forward to seeing you in the near future.

Sincerely,

Barbara Jones

THE EXHIBITION PROPOSAL LETTER TO A GALLERY
BY FRANK BRUNO, ARTIST

The proposal is often asked for after an initial gallery mailer has been positively received. In this case the gallery director was impressed by my work from a previous packet sent to him and wanted to know my specific ideas for a solo exhibition.

All detailed descriptions of your planning should be itemized accordingly. Be sure to remain polite and to respect the director's position and ultimate decision-making. Notice that I continuously mention that any and all final executions are contingent upon his approval.

You may have the most creative intentions in the world but you must remain aware of acceptable conditions. Additional fine-tuning to your proposal may be required. This is not uncommon. It's a good idea to have an alternate plan(s) ready for any contradicting feedback. Notice since I was unsure if my Caution Tape usage would be accepted I suggested the alternative title to be simply "Figural Fragments" instead of "CAUTION... Figural Fragments." If my idea for using the tape was rejected it may have weakened the impact of the entire show. I made sure to keep referring to it throughout my proposal as an integral part without overemphasizing its presence or detracting from the focus being the art.

Mr. John Doe
Smith Gallery at Blooms University
123 East First St.
Blooms, PA 10000

Dear Mr. Doe,

I hope all is well with you. Thank you for your prompt response to my previous mailer. As promised, enclosed is my exhibit proposal, which outlines all of my ideas in detail.

Also included are more samples of my work, which I plan to include in the "CAUTION... Figural Fragments" exhibit. This show will be widely advertised with the aid of Press coverage, a large number of invitations designed by me (at your discretion) and perhaps a video, which I would arrange through my affiliates.

I look forward to this opportunity in what I feel will be a very interesting, thought-provoking show. Again Mr. Doe, I welcome any ideas you may have, as input from you is most important to me.

Sincerely,

Frank Bruno, Artist

THE EXHIBITION PROPOSAL BY FRANK BRUNO, ARTIST

Editor's note: This is a proposal, not a final contract. Additional details must be addressed in a separate document signed by both parties. See the section on Agreements and Contracts.

OBJECTIVE:
A strong solo exhibition consisting of abstract / impressionistic painterly figural art created in acrylics and oils on canvas and wood panels.

TIME TABLE:
Exact dates to be determined contingent upon final approval. Preferably for a one month period in the year 2004.

TITLE:
"CAUTION... Figural Fragments" or simply "Figural Fragments" contingent on the use of "CAUTION TAPE" suggestion.

EXECUTION:
To display approximately 20 to 30 pieces of presentable two-dimensional artwork of varied sizes throughout the gallery space.

MATERIALS NEEDED:
At the discretion of the gallery I will provide all crucial materials. I will supply small promotional materials, such as an on-view portfolio. Some loose sketchbooks will be available for people to browse through that will add to a studio-like environment.

PROMOTION / ADVERTISING:
In addition to any Press materials supplied and sent by Smith Gallery, I will prepare and send Press Releases one month ahead of fixed date (to be determined) to any and all immediate area newspapers, art organization newsletters, and periodical art magazines. I am willing to research additional coverage in the form of local television coverage and other connections that might generate interest.

COSTS:
I agree to the gallery's 35% commission structure. Other costs to be discussed.

MISCELLANEOUS:
As a creative element, I wish to use a moderate amount of bright yellow "CAUTION" tape to be displayed at certain areas of the gallery, and in such a way that will not deter any potential viewer.

The Artist agrees to participate in "Meet the Artist" events arranged by the University for students, faculty and the public.

Frank Bruno is a successful artist and artist career advisor and coach living in Collegeville, PA. For more information see the Resource section of this book.

WRITING TO A MEMBER OF THE PRESS

To see one's name in print!
Some people commit a crime for no other reason.
Gustave Flaubert

Aletter to the press can be extremely helpful in bringing your publicity materials to the attention of a particular producer, editor or reporter. In most cases, the letter is a professional introduction and a way to emphasize important items contained in the press release. A cover letter mailed with a press release and visual images offers you the chance to explain *why* you would be the right story for their readers or listeners. This is called a pitch letter. Its purpose is to generate interest and encourage them to write about you and/or your work.

QUICK TIPS

- Follow the same guidelines as the business letter to a gallery.
- Establish rapport by addressing the letter to a specific person.
- If the press release runs two or more pages a concise, one-page cover letter is attached that encapsulates the essential details. The editor can refer to the press release for more details.
- A cover letter may be attached to press materials *after* an event, to keep the interest going. An excellent example of this is the letter I received from the Metropolitan Museum of Art following a press luncheon. Since I did not attend the luncheon, they mailed the press materials that were distributed to those who did attend.
- A cover letter can serve as a personalized invitation to the member of the press when mailed with a printed postcard to announce an exhibition.
- If you have spoken to a member of the press, and they have expressed interest in receiving materials, then the cover letter is a good way to remind them of the conversation you had. Take notes during the conversation, which you can refer to later.
- If the cover letter is a form letter a good way of personalizing it is by adding a hand-written note at the top or bottom of it.

(Also read the section on Raising The Volume on Self-Promotion.)

This letter was sent to *Manhattan Arts International* magazine. Its style is effective for specialized art publications as well as general interest publications.

Notice the tone of the letter. It gets your attention and is informative and friendly.

The letter gives the reader more than one good reason why this is an important event to attend and write about.

Solomon R. Guggenheim Museum 1071 Fifth Avenue Telephone: 212- 423- 3500
New York, NY 10128 Telefax 212 423 3650

Dear Colleague:

The Guggenheim Museum is proud to announce a landmark event this fall: the first full career retrospective of Robert Rauschenberg to be presented in this country since 1976. Rauschenberg is an American original celebrated for his creative exuberance and for redefining contemporary notions of art. He has been described by a leading critic as "the enfant terrible of American modernism." This exhibition will give audiences an opportunity to see new work by the artist within the context of his entire oeuvre.

Robert Rauschenberg: A Retrospective opens September 19, filling the entire Solomon R. Guggenheim Museum and the Guggenheim Museum SoHo, including newly created gallery space on the third floor of the Guggenheim Museum /SoHo. Attached is further information; color and black and white images of works in the exhibition are also available upon request.

We look forward to welcoming you to this major art world event in September. If you have any questions in the meantime, please contact me at the phone number below. Thank you.

Sincerely,

Ulika Brand
Senior Publicist

SAMPLE OF A PITCH / COVER LETTER TO THE PRESS

This letter was written in a short and concise memo style.

The personalized invitation with words such as "We would be most honored..." is an effective approach to attract the reader's interest and make them feel special. The style of the letter is friendly yet professional.

Notice how this format could be adapted to accompany materials you may want to send via fax.

Regina D'Amato

MEMO TO: Renée Phillips, Editor-in-Chief
Manhattan Arts International

FROM: Regina D'Amato
Amato Communications for Juliet Marion, Artist

RE: Juliet Marion's Solo Exhibition

DATE: January 5, 2003

Dear Ms. Phillips,

I have attached an invitation to Juliet Marion's opening, which will take place the evening of January 26 from 6 – 9 pm at The Plaza Gallery. We would be most honored if you could join us. Paul Cadman, who has written the Introduction to the show catalogue, will attend.

You will also find a complete press kit on the show, which will run until March 1. I will contact you to see if you need any additional information. In the meantime, if you have any questions you can reach me at 555-123-4567.

Again, we hope to see you on the 26th.

Sincerely,

Regina D'Amato

SAMPLE OF A FOLLOW-UP LETTER AFTER A PRESS EVENT

Keep the interest in your project or exhibition alive after the opening reception.

This letter was mailed to *Manhattan Arts International* magazine after a press luncheon at the Metropolitan Museum that we were unable to attend. Imagine how appreciative we were to receive a letter like this.

The Metropolitan Museum of Art

VICE PRESIDENT FOR COMMUNICATIONS

Dear Colleague:

We regret that you were unable to attend the November 24 press luncheon at the Metropolitan. As you know, Museum Director Philippe de Montebello offered a preview of our schedule of forthcoming exhibitions and installations through the summer of 1998. And Museum President William H. Luers made an important announcement about our capital campaign, the Fund for the Met.

I thought you would be interested in receiving the materials we distributed to our guests at the event. A copy is enclosed.

Please do feel free to call on me, or any member of our staff, if we can provide additional information on any or all of these news releases.

We look forward to seeing you at our next press lunch here at the Met.

Sincerely,

HAROLD HOLZER

SAMPLE OF A FOLLOW-UP LETTER AFTER AN ART OPENING

Barbara Jones
123 Fourth Avenue, Bellmont, VT 00000 Telephone: 111-222-3456

Date

Renée Phillips
200 East 72 Street
New York, NY 10021

Dear Ms. Phillips,

Your presence was missed at the opening reception for my exhibition "The Queen's Moves in the Game of Chess." Please allow me to extend another invitation to you to see the show which runs through April 20th at the Art Gallery in High College. Gallery hours are Tues.-Sat. 11-6.

It is with great pleasure to enclose a copy of the exhibition catalogue, which contains reproductions of all 23 works in the exhibition, as well as an introduction by Maria Magnoni, the curator of the exhibition. The artist's résumé and artist's statement are also attached.

Color transparencies and black and white photographs are available if you need them. I would be most delighted to meet you or a representative from your magazine at the gallery to discuss the work.

Thank you for your interest. I hope to speak to you at your earliest convenience.

Sincerely,

Barbara Jones

SAMPLE OF A FOLLOW-UP LETTER AFTER A CONVERSATION

Send a follow-up letter after an important conversation or meeting. The letter will serve as a reminder of the essential details discussed during the conversation.

Remind the recipient that he or she requested the materials. You might want to write "Enclosed: The materials you requested" on the outside of the envelope.

<div align="center">

Barbara Jones
123 Fourth Avenue, Bellmont, VT 00000 Telephone: 111-222-3456

</div>

Date

Alexandra Shaw
Features Editor
Manhattan Arts International
200 East 72 Street
New York, NY 10021

Dear Ms. Shaw:

Thank you for taking the time on the telephone to discuss my upcoming exhibition. It was a pleasure to speak to you. In our conversation you mentioned my work might be of interest for your series of articles on Asian-American artists.

As you requested, I am enclosing an article written about me by Lee Chow, noted Chinese historian. To further acquaint you with my work I am also enclosing six 8" x 10" color photographs, my artist's statement, and my biography. There is an additional review attached that was written by your colleague Marcy Hall, during my last exhibition at Bergert Fine Arts.

Please contact me if you need any additional materials. I look forward to hearing from you.

Sincerely,

Barbara Jones

THE ARTIST'S NEWSLETTER

A POWERFUL METHOD OF SELF-PROMOTION

Nothing great was ever achieved without enthusiasm.
Enthusiasm is the powerful engine of success.
Ralph Waldo Emerson

It is important to keep your friends, colleagues, associates, agents, buyers and prospective buyers abreast of your achievements throughout the year. You can do this using a variety of methods that suit your budget, time and personality. In addition to the conventional postcard, some artists, with the aid of their computers, create a one or two page newsletter that announces their recent activities.

A newsletter is an inexpensive yet highly effective method of self-promotion. It helps you to reach out to people familiar with your work and keeps them informed of your accomplishments. A successful letter will be one they will look forward to receiving. It will consistently remind them that owning your work is not only an enjoyable experience, it is also a wise investment!

QUICK TIPS

- The best letters are composed of short, concise paragraphs that enable you to share your news with ease and interest.
- The tone should be professional, friendly and enthusiastic.
- Keep the length to no more than four pages.
- Feature reproductions of your work. Make them as large as the space will accommodate.
- Design the letter so that each page is an attractive balance of visual images and text.
- Use bold headlines and white space to create visual resting areas.
- Make the process of writing newsletters a regular habit, before, after and in-between exhibitions.
- A good time to send newsletters is the end of the year when you can wish them season's greetings and a Happy New Year.
- Create your own format to reflect the style and personality of your work.

- Emphasize your accomplishments as well as your future endeavors.
- Share the news about your exhibitions, new works, commissions, travels, workshops, limited editions, awards and sales.
- A successful letter will encourage the recipient to share the triumphs of your career, and they will be more apt to participate financially. They will also want to share the news with friends and colleagues, thereby becoming some of your best representatives.
- Many artists mail greeting cards *before* the holidays and their newsletters *after* the New Year, so that their important letters don't get lost in the stack of holiday cards and their recipients have more time to read them and reply.
- You may enclose order forms for selling your new limited edition prints, note cards or other art-related products.

THE SEASONAL NEWSLETTER

BY ANNIE SHAVER-CRANDELL

Annie Shaver-Crandell's first newsletter titled "Think Visually, Act Locally" was mailed in the winter of 2002 to "Dear Friends." Her New York studio is about one mile and a half north of Ground Zero. Having been an observer of the horrific events of September 11th, she was compelled to create a painting to express her feeling of powerlessness in the face of tragedy. To read her profound story accompanied by her exquisite work was a very inspiring and healing experience.

Annie's newsletter was printed in color from her computer on an 11" x 17" sheet of paper folded to four 8-1/2" x 11" pages. In addition to featuring four of her watercolor paintings in a very clean magazine style format she shared her "Art-making highlights", "Recent exhibition venues" and "Reproductions" (publications that had recently featured her work). In the closing she extended an invitation to an art brunch at her loft.

The newsletter was friendly, professional and historical. I'm sure it will be treasured by those of us who received it for a long, long time.

THE END OF THE YEAR NEWSLETTER

BY GAYE ELISE BEDA

Gaye Elise Beda creates an "End of the Year Wrap-Up" and mails it to her collectors, dealers, friends, relatives and critics – and everyone else who has expressed an interest in her work.

The letter consists of one or two 8-1/2" x 11" pages and announces her recent achievements including honors and awards, books and publications that feature her work, solo and group exhibitions and travels. It also features her most recent paintings. This annual mailing reminds every person who receives it that she is dedicated to growing her artistic and career goals.

"These letters are my best sales people," the artist says. "My collectors look forward to receiving it every year. If they have moved, they contact me with their new address so that I can send them the most current update. They keep all the letters on file and share them with their friends and relatives." Her "End of the Year Wrap-Up" has led to many unexpected surprises, including being featured in her alma mater's magazine. When you spread the word about your accomplishments, you never know what will happen. You create many possibilities for publicity and sales.

Gaye scans photographs of her work and creates the newsletter using Quark XPress and Adobe Photoshop. Any word processing program will also suffice. She uses an Epson color laser printer to make copies. She strongly recommends that artists familiarize themselves with various computers, programs, scanners and printers before making any purchases. She urges artists to, "Find out what is best for them, what best reproduces their artwork, and what their professional needs are before making the investment."

When the artist is alive in any person, whatever his kind of work may be,
he becomes an inventive, searching, daring, self-expressing creature.
He becomes interesting to other people.
He disturbs, upsets, enlightens,
and he opens ways for a better understanding.
Robert Henri

E-MAIL CORRESPONDENCE

Art is a language, instrument of knowledge, instrument of communication.
Jean Dubuffet

E-mail correspondence is undoubtedly a flourishing method of communication. It is the form of choice for many obvious reasons, including the money saved on envelopes and postage and its wonderful convenience and immediacy. Today, we are able to communicate with thousands of individuals around the world with record-breaking speed.

Its easy access and speed are no excuses for ignoring many of the professional rules that apply to writing a conventional business letter. Here are some tips on e-mail etiquette:

QUICK TIPS

- Type your e-mail neatly and check for accuracy, grammatical and typographical errors; and obtain the name, correct spelling and gender of the person in charge and mail the material directly to him or her.
- Keep your letters concise and to the point. The process of reading e-mail is different than snail mail – time and attention are limited.
- Sending an e-mail with a link to your website may be a very productive means of promotion to those who know you, however, unsolicited e-mail with links may not be an acceptable means of introduction and may be ignored by the recipient. Most professionals we interviewed prefer to be introduced to artists' work through printed visuals first. It is best to find out first before sending it.
- If you are considering sending unsolicited attachments with your e-mail you may want to discuss it with the prospective recipient first, since many people are concerned about catching computer viruses and may ignore your file if they don't know who you are. That would be a waste of your time.
- Most individuals dislike getting spammed. If you are sending e-mail to several people in your address book, at least have the courtesy to hide the additional e-mail addresses. Send the batches using the blind copy process, or send them individually.
- Be courteous. Respond to e-mail you receive within 48 hours. If you cannot respond fully, at least e-mail a note stating you appreciate their e-mail and will respond on or before a specific date. Also, find out if your provider has a service that automatically sends a response.

THE RÉSUMÉ

LISTING YOUR PROFESSIONAL ACHIEVEMENTS

At the age of six I wanted to be a cook.
At seven I wanted to be Napoleon.
And my ambition has been growing steadily ever since.
Salvador Dali

A résumé is also known as a curriculum vitae or CV. It is a track record of your professional history. It is the compilation of the awards you have won, the venues in which you have exhibited, the commissions and publicity you have received, the kinds of collections your work has entered and the art-related activities you have experienced.

In the business of art you are not always judged on the quality of your art. In fact, people are influenced by professional achievements and form their opinions, and make their decisions, accordingly. Prospective buyers, for instance, may be impressed to see a certain level of collectors on your résumé, whereas a grant-giver may be more interested in your intent and artist's statement in addition to the honors, awards and other grants you have received.

It is the strength not the length of your résumé that matters. If you are a beginning artist, don't be embarrassed if you have nothing to list. Instead, look at your résumé as a work in progress, with many opportunities and accomplishments awaiting you. Avoid feeling pressured to quickly pile up mediocre credits. Resist the temptation to pay for an exhibition in a "vanity" gallery; it will probably be counter-productive. There are many alternative exhibition spaces, including non-profit spaces, corporate lobbies and cultural centers that offer new artists exposure.

Your résumé reflects the kinds of choices you have made in your career. A résumé also informs the reader how you stand among your peers. Keep this in mind as you build your professional history. Assume responsibility for the course of your destiny. Set short and long-term goals every step of the way. *(Read the section on Laying The Foundation For Success: Planning Your Goals & Strategies.)*

People usually fail when they are on the verge of success.
So give as much care to the end as to the beginning;
then there will be no failure.

Lao Tsu

CONTENTS OF A RÉSUMÉ

- Name, Address, Telephone, Fax, E-mail and Website addresses.
- Place of birth. Date of birth.
- Exhibitions in galleries, museums and alternative spaces. List one-person (solo) and group exhibitions separately if you have more than three in each category; otherwise list them together and place an asterisk (*) next to one-person exhibitions. List them in reverse chronological order (most recent exhibitions first). Also list scheduled, up-coming exhibitions. List curators of exhibitions when applicable. Note whether the exhibition was juried or invitational. If you received an award in the exhibition, also include it under the next category.
- Grants, Honors and Awards.
- Bibliography (may also be titled Articles and Publications): List, in reverse chronological order, writer's name, title of article, publication and issue date of reviews and articles that have appeared in newspapers, magazines, books and catalogues.
- Published Writings: Art-related articles or books you have written.
- Radio and TV Appearances.
- Commissions: Title of piece or the project, sponsor and location.
- Private and Public Collections: Owners of your work.
- Art-related (or Career-related) Activities: Lectures, teaching experience, workshops, demonstrations, artist-in-residence programs, curatorial and jurying experience, public art projects and officer positions in art organizations.
- Education: Years attended, degrees, schools and private instructors.

QUICK TIPS

- Choose a fine quality paper: 25% cotton bond, heavy weight, in a bright white, white or neutral beige or ivory. Avoid the use of brightly colored paper.
- Use a readable typestyle.
- The headings should stand out from the listings; use caps, bold, or a larger type size.
- Listings in each category are arranged in reverse chronological order.

- Although a résumé is somewhat standardized and usually begins with the exhibition listings, you should arrange the categories to highlight your strongest achievements. Many artists think they need to begin their résumés with education, although other accomplishments you achieve after graduation have more significance as a professional artist.
- If you have fewer than three listings under the categories, you may prefer to use the biography (your history in prose style) until your résumé grows.
- As your professional history develops, keep the résumé up-to-date and rearrange the format to fit your targets.
- When your complete résumé exceeds two or three pages, delete less significant listings. You can use the terms "Selected Exhibitions" and "Selected Collections" to indicate you have edited your résumé. At the end of the resume, you may add these words: "A complete résumé, which is (x number) pages, is available upon request."
- If you are age sensitive, you do not have to list your date of birth or the years you attended school, however, you shouldn't be ashamed of being "too young" or "too old." If someone rejects you on the basis of age then go somewhere else.
- Do not include positions unrelated to art.
- Use the same letterhead for your letters, biography and artist's statement.
- Make your name and contact information on your letterhead easy to read.
- Select a different type style for your name and address. These elements should stand out from the category headings and the listings.
- Résumés of other artists serve as guideposts. Study the résumés of successful artists in galleries where you want to be shown. Look for clues in their career path – where they exhibited, which public collections their work is in, what critics have given them favorable reviews. Use the contacts as a compass to guide your own career.
- To build the exhibition section of your résumé join art associations that exhibit their members' art in galleries and museums and enter juried exhibitions sponsored by art organizations. Concentrate on developing your artistic skills and exhibitions and other opportunities will follow.

Today, each artist must undertake to invent himself,
a life-long act of creation that constitutes
the essential content of the artist's work.
The meaning of art in our time flows from this function of self-creation.
Harold Rosenberg

SAMPLE OF THE RÉSUMÉ

Barbara Jones

123 Fourth Avenue, Bellmont, VT 00000 Telephone: 111-222-3456

SELECTED EXHIBITIONS

List in reverse chronological order – upcoming and most recent exhibitions first.The year is followed by title of the exhibition (unless it is a one-person show with no title), juror or curator, location, city, state and country if outside the country of origin. Combine one-person and group exhibitions unless you have three or more one-person exhibitions.

(* One-Person Exhibitions)

2004 "Seven Painters", curated by Joe Smith, ABC Cultural Center, New York, NY.

2004 * Blue Gallery, Phoenix, AZ.

2003 "Calligraphy/Watercolors", New York Public Library, Donnell Center, New York, NY.

2003 * Toma Gallery, Bridgeport, CT.

HONORS & AWARDS

Include cash and other awards, honors of distinction, grants and fellowships.

2004 Award of Excellence, *Manhattan Arts International magazine* Cover Art Competition. Juror: Edward Rubin, NY Art Critic, *New Art Examiner*

2004 $1,000 Cash Award, Kent Foundation, New York, NY. Juror: Alvin Kent, Director, Krasdale Foundation.

2004 Artist Showcase Award, www.ManhattanArts.com Small Works 2004 competition. Juror: Nancy di Benedetto, art historian and lecturer, Metropolitan Museum of Art.

2003 Certificate of Merit, Calligraphy Festival, Tokyo, Japan. Juror: Akiko Tamayama, Curator, Tokyo Art Center, Tokyo, Japan.

BIBLIOGRAPHY

Include all published articles that mention your name. List the year in which it appeared, writer's name, title of the article enclosed in quotation marks, name of publication in italics, and issue date. You may also include directories and catalogues.

2004 Jim Doe, "John Smith Creates Evocative Assemblages", *Arts Review,* Spring

2003 Catalogue, "Artists of America", International Exhibition, Golden West College, Huntington Beach, CA

2003 Joseph Mooney, "Watercolor Painting", *Artist Magazine,* May

SELECTED COLLECTIONS

List the name, city, state, and country. If you have several in each category (private and public), you may use two separate categories with the headings: PRIVATE COLLECTIONS and PUBLIC COLLECTIONS. You may also choose to list only Public Collections.

ABC Corporation, Houston, TX
Belmont University, Falls, UT
Mr. And Mrs. Jay Smith, Dallas, TX

CAREER-RELATED EXPERIENCE

List lectures, demonstrations, workshops, teaching experience, curatorial positions, and other art related activities.

2004	Co-Curator, "Seven Painters", ABC Gallery, New York, NY
2003	Painting Workshop, The Council of the Arts, New York, NY
2003	Artists Speak Out, slide show, The Gallery, Gardenville, NY
2003	"Is Painting Dead?" panel discussion, The Apple Museum, Washington D. C.

PROFESSIONAL MEMBERSHIPS

List art organizations and any positions you have held.

2001-present	President, Contemporary Artists of New York Artists Group
2000-present	New York Artists Equity Association
2000	Vice-President, The Watercolor National Art Group

EDUCATION

List your degree(s), specialization, name of university or art school. You may also list private study, workshops, and travel-study programs.

1995	M.F.A., Painting, ABC University, Boston, MA
1990-91	Kalamano Painting School, New Balio, NJ
1992	Sheering Workshop, Mendocino, CA
1977-78	Fashion Institute of Technology, New York, NY

SAMPLE OF THE RÉSUMÉ

Barbara Jones

123 Fourth Avenue, Bellmont, VT 00000 Telephone: 111-222-3456

Flight, oil on canvas, 24" x 48"

One-Person Shows* & Major Exhibitions
2004	*National Watercolor Association, Los Angeles, CA
2003	"Painters in the Northeast", Regional Alliance Artists, New York, NY
2003	"New Works", Pastel Society of America, Houston, TX
2002	*Grand Case Gallery, High Town, MI
2002	*White Hills Gallery, Dallas, TX

Commissions
"Peace", mural for the lobby, ICP Corporation, Brookline, MA

"Dove", pastel, National Academy, Phoenix, AZ

"Florence Gardens", watercolor, ATO, Madrid, Spain

"Reaching", pastel, Falls Corporation, Falls, MA

"Angels", pastel, Meikson Institute, New York, NY

Awards
2004	First Place, US Pastel Society. Juror: Armon Smoler, curator, Ame Museum, Dallas, TX
2003	*Manhattan Arts International* Artist Profile Award, New York, NY
2003	Shakespeare Art Award, Pottsdale, AZ
2002	Silver Medal, Alliance Arts, Palette, OR
2000	First Place, Holland Valley Arts Group, Chicago, IL

Articles and Publications
December 2004, *Architecture Week,* Cover Story, Tom Miller

September 2003 , *Manhattan Arts International,* Cover

October 2000, *U.S. Arts,* "Artfully Speaking", Judy Light

Lectures
2002	"How to See", Drawing Club, Atlanta, FL
2001	"Is Painting Dead or Alive?", Allied Museum, Tuxedo, NY

THE BIOGRAPHY

TELLING YOUR STORY

I became an artist
for the same reason I became a writer –
I wanted to tell my story.
Faith Ringgold

A biography contains much of the same information as a résumé, however, it is written in paragraph form, as compared to the listing form of a résumé. It often elaborates on your life's story as it relates to your art career and the journey you took to get there. You can add some interesting features to the biography that will entice the reader.

A biography may accompany a résumé or ride alone. For the beginner artist it may the best format until you can list a sufficient number of credits in each category of the résumé such as "Exhibitions", "Honors and Awards", "Bibliography" and "Commissions."

USES FOR THE BIOGRAPHY

- To emphasize the most important achievements listed on your résumé.
- To use until you have substantial listings needed to prepare your résumé.
- To provide material for part of your cover letter.
- To accompany a press release to an art editor or feature story editor.
- To serve as an integral part of a brochure or catalogue.
- To provide to those interested in hiring you for a lecture, workshop or panel discussion.
- To accompany a grant proposal.
- To accompany your artwork on a website.

CONTENTS OF THE BIOGRAPHY

- Where and when were you born?
- Where have you lived and where do you currently live?
- Did you come from a family of artists? What is your family background?
- When and where did you begin to take interest in art?
- Did you study art in school, or were you self-taught?
- Did you go to college? Where? What did you study?
- Did you study with well-known artists?
- What or who inspired you to become an artist?
- Where have you exhibited your work?
- Is your art in any important collections? Which ones?
- Have you traveled extensively? Where?
- How have hobbies, special interests or experiences influenced your art?
- How have other career paths influenced your art?
- What organizations do you belong to?
- What awards and other professional achievements have you earned?
- Have you volunteered your artistic talent in any social, educational or political groups?
- What unusual experiences have occurred in your life?
- What creative innovations have you achieved?

QUICK TIPS

- If your biographical information is short, you might want to add a short description of your artistic philosophy or approach to art.
- You may feature a reproduction of you and/or your work on the same page of a short biography.
- Avoid personal items that are not related to your career or artistic vision.

Continuous effort,
not strength or intelligence,
is the key to unlocking our potential.
Winston Churchill

SAMPLES OF THE BIOGRAPHY

DELLAMARIE PARRILLI

Dellamarie Parrilli has a celebrated background in music, performing and visual art. Heralded by the *Las Vegas Press* as a "triple threat" because of her talent as a singer, dancer and actress, she is now creating paintings that are inspirational, illuminating and transcendent of the ordinary. Ed McCormack, Editor-in-Chief of *Gallery & Studio* stated that Dellamarie Parrilli "possesses a natural fluidity that enhances the immediacy of her canvases immeasurably, imbuing her compositions with rhythmic vigor and vitality." She was featured on the cover of *Booster* and articles about her have appeared in many publications including the *Chicago Tribune* and *Skyline*.

She is the recipient of the Richard W. and Wanda Gardner Memorial Award and Manhattan Arts International "Artist Showcase" Award. Her work has been exhibited widely throughout the U.S. including a one-person exhibition at the Fine Arts Building in Chicago, IL, and group exhibitions at the Hunter Museum of American Art, Chattanooga, TN; Limner Gallery and Cork Gallery, Lincoln Center, New York, NY; and Central Wyoming College Gallery in WY; among others.

The artist's work is in numerous private and corporate collections including those of Lucinda Williams, recording artist; Lt. Governor Kathleen Kennedy Townsend; Busse Wellness Center Ltd; and Dragon's Life System Inc.

She earned a BA from DePaul University, School of Music, and continued studying voice, dance, and improvisation for several years. Throughout her career as a performing artist Parrilli studied painting with the renowned artist John E. Williams. She also studied metalsmithing and jewelry design.

RICHARD MAYHEW

Considered one of America's greatest landscape painters, Richard Mayhew has had over 30 solo exhibitions. He was born in Amityville, NY to Native American and African American parents.

His works are in the permanent collections of The Metropolitan Museum, The Whitney Museum and The Brooklyn Museum, NY; The Art Institute of Chicago, IL; The Smithsonian, D.C.; and Los Angeles County Museum, CA; among numerous other national and international public and private collections.

Following his first solo exhibition in 1955 at The Brooklyn Museum, he received a John Hay Whitney Foundation grant to study in Europe. Upon his return in 1963, he and other intellectuals founded "Spiral," an influential group of black artists who were united in their dedication for civil rights in the art world. Like the Archimedian spiral symbol, from which the group took its name, his reputation is being recognized in ever widening circles.

SAMPLES OF THE BIOGRAPHY

PATRICIA BROWN

Patricia Brown is an abstract painter living in California. She works in a range of media including oil, acrylic, watercolor, mixed media, and collage. Her paintings have won numerous awards including the Award of Excellence from *Manhattan Arts International* Magazine and the Award of Distinction by Rockport Publishers.

She has had many one-person exhibitions including those at the Half Moon Bay Museum, CA, Grants Pass Museum of Art, OR, and Gallery One in Ellensburg, WA. One of her paintings was selected by Ambassador Maisto for an exhibition at the U.S. Embassy in Managua, Nicaragua.

The artist's work has appeared in many fine art publications. It was featured on the title page and other pages of Rockport Publishers' book "The Best of Sketching and Drawing" in addition to "Creative Inspirations" and "The Best of Oil Paintings" also published by Rockport. She was selected as one of the "Artists in the 1990's" in *Manhattan Arts International* magazine.

Among Patricia Brown's other honors are the inclusion in Broderbund Software's edition of Print Shop Deluxe and Version 6 of Print Shop. Her painting "TheVineyard" was chosen by James Tobin Cellars for their wine label to be on their varietal wine Viognier.

KATHY FUJII-OKA

Kathy Fujii-Oka was born in 1957, in Berkeley, CA and has been painting since childhood. Primarily self-taught, she earned an Associate in Arts at De Anza College, Cupterino, CA. She is currently a full time artist living in CA with her husband Preston and daughter Brittany.

The artist's work has been featured in many exhibitions throughout the U.S. including those at the Euphrat Museum and Yamagami's Garden Room, in Cupertino, CA, and the Papp Gallery and Atlantic Gallery, both in New York, NY.

Fujii-Oka was recently awarded the Artist Showcase Award in the Manhattan Arts International Annual "Herstory" competition and her painting is exhibited in the online gallery at www.ManhattanArts.com. One of the jurors Renée Phillips, a member of the International Association of Art Critics, stated: "Her work was selected because it reveals extraordinary skill and expression."

Her work has been published in the *International Women Artists*, Vol. 2 and was the cover story of the *Cupertino Courier*. She has also been the topic of a program on Art Scene, KKUP-FM Radio.

SAMPLES OF THE BIOGRAPHY

LEONORA CARRINGTON

Leonora Carrington was born in Clayton Green, England, in 1917. In 1936, she gained international recognition when she exhibited at the International Surrealist Exhibition in London with the members of the surrealists, among them Rene Magritte, Salvador Dali, Max Ernst, and Yves Tanguey. That was the beginning of the Surrealist's glimpse into her magical world. Due to the outbreak of World War II, she moved to Mexico City in 1942, with the Mexican diplomat Renato Ludic, whom she had met through Pablo Picasso. For the next several decades, she made Mexico her adoptive land and kept close ties with artists such as Gunther Gerzo, Luis Bunuel, Frida Kahlo, Wolfgang Palen, Benjamin Peret, Octavio Paz, and Remedios Varo. Still residing in Mexico, Carrington is a major presence in its artistic community.

Leonora Carrington has been a recipient of numerous awards and distinctions. Most recently she was honored with retrospectives at the Museo de Arte Contemporáneo de Monterrey (MARCO) and The Museum of Modern Art in Mexico City. She has also received world-wide recognition for her unique writings: *The Stone Door* (novel), *The Hearing Trumpet* (novel), *House of Fear* (stories), *Notes from Down Below* (autobiography), and *The Seventh House and Other Tales* (stories). Both her art and her fiction have been the subject of numerous books, biographies, periodicals, and films.

MARK DI SUVERO

Mark di Suvero was born in Shanghai in 1933, to Italian parents. In 1941, his family immigrated to the U.S. and settled in San Francisco. Di Suvero moved to New York in 1957, where he participated in his first group exhibition at the March Gallery, showing plaster and wood constructions. As part founder of the Park Place Gallery in 1962 di Suvero exhibited some of his earliest wood and steel sculptures through 1967.

Major exhibitions of di Suvero's work have been held nationally and internationally, in museums and city-wide exhibitions such as: Le Jardin des Tuileries, France and the Whitney Museum of America Art both in 1975; Stuttgart, Germany, 1988; the City of Valence, France, 1990; Chalon-sur-Saone, France, 1992; and the Venice Biennale, 1995. In addition, di Suvero was the subject of two major one-person exhibitions at Storm King Art Center, New York, in 1985 and 1995 and the city-wide exhibition "Mark di Suvero in Paris," France, 1997. Other large-scale sculptures can be seen at the Storm King Center as well as St. John's Rotary in New York City.

Mark di Suvero lives and works in New York, California, and France.

THE ARTIST'S STATEMENT

EXPRESSING YOUR ARTISTIC VISION

Your style is the way you talk in paint.
Robert Henri

The artist's statement is a brief narrative that describes the body of your work and its meaning. It is often the only tool the observer of your work has to fully understand your work, the way you intended it to be understood. It also serves as a promotional tool to avoid misinterpretations of your work.

The artist's statement offers you the opportunity to express your artistic vision. It demonstrates that you know the content of your work, that you are serious about the direction you are currently taking, and that you have the ability to communicate clearly.

The artist's statement serves as a useful *written* tool that accompanies other presentation materials when approaching dealers, art consultants, collectors, grant givers and the press. It also serves as a basis from which to develop a *verbal* response when someone asks you about your work. In our fast-paced society, there are many times you will be faced with little time to describe your work. As an artist you should be prepared with a succinct and meaningful explanation at a moment's notice.

Although challenging, the process of creating an artist's statement can be enlightening and informative. It will assist you in the clarification of your creative goals. An artist's statement is very constructive for artists who change their focus frequently. It is useful if you work in different series: You may want to prepare a different statement for each.

An artist's statement that is poorly written or contrived may do more harm than not having one at all. Do not force yourself to write one until you have strong feelings about the motivation behind your work. Have patience and it will write itself.

The artist's statement is used in part or in its complete form for a number of important tools including:

- Cover Letter to a Gallery
- Biography
- Grant Proposal
- Juried Competition
- Exhibition Proposal
- Curator Proposal
- Press Release
- Exhibition Catalogue
- Promotional Brochure
- Your Verbal Introduction
- Agents' Sales Presentation
- Artwork in an Exhibition
- Artwork on the Internet
- Public Speaking Opportunities

An artist cannot speak about his art
any more than
a plant can discuss horticulture.
Jean Cocteau

QUICK TIPS

- There are no prescribed formulas for writing your artist's statement.
- It is important to find your own voice and not to copy that of another artist.
- Write it in the first person.
- Keep your length to one, double-spaced, typewritten page.
- Discuss your outlook, inspiration, ideas, vision, philosophy and revelations.
- Use "picture words" to express yourself in the most articulate manner.
- Simply explain why you do what you do.
- Explain the motivation behind your process.
- Explain how your work develops and evolves during the creative process.
- Describe your medium and your style.
- Relate your technique and style to your medium and your vision and philosophy.
- Discuss the way(s) in which your work, medium, technique or vision is unique.

- If appropriate mention your use of ancient or modern symbols or historical influences.
- If you work in series, explain how they are connected – if they are.
- If you work in series but they are dissimilar write a different artist's statement for each series of work.
- Be honest.
- Avoid being pompous.
- Avoid grandiose and empty expressions.
- Avoid simplification.
- Avoid being overly technical.
- Avoid self-doubt statements such as "I try to…"
- Avoid repetition.
- Avoid the use of jargon and cliché.
- Vary sentence structure and length.
- Adjust the length of your sentence to relate to the complexity of the idea.
- After you write your artist's statement, try it out on someone who is not involved in the art world to ensure its clarity.
- Have someone who is good with grammar proofread it for you to check for misspelled words and typographical errors.
- If you find the task extremely difficult, don't hesitate to obtain some coaching or editing from a professional art writer.
- To help you get started keep a journal to record your ideas, before, during and after a creative session in the studio.
- Write your ideas as they come to you. Write them in a free-association style. Do not censor or edit your thoughts.
- Begin by writing words, then phrases, and before you know it, you will have complete sentences and whole paragraphs.
- Tape-record your ideas and conversations about your work.
- Store your artist's statement in your computer for easy updating.
- The exercise of writing an artist's statement requires practice. Don't give up if you don't get it right on the first try.

Truth in art is the unity of a thing with itself:
The outward rendering expressive of the inward:
The soul made incarnate: The body instinct with the spirit.
Oscar Wilde

SAMPLES OF THE ARTIST'S STATEMENT

JENNIFER BARTLET

I have tried to put myself in a position where taste is not an issue so that I could avoid picking the same alternative over and over again. This demands being more thorough and completing more things. I am trying to explore all possibilities, which requires that I have to be more flexible in the scale of the work.

If a painting is comprised of units, it is possible to think of it as always being divisible or changeable. The gridded steel plates allow me to approach painting in a very methodical manner, where each thought can be seen as if it were a clause. The white spaces between the plates act as punctuation – they function like the space between works and sentences, dividing one unit from another.

SUSAN ROTHENBERG

I am an image maker who is also an image breaker – trying for a little more. The geometries in the paintings – the center line and other divisions – are the main fascinators. They were there before the horse. The subject of my paintings has to be able to carry the concern with the divisions. First I do the lines and then the horse may have to push, stretch, and modify its contours to suit the ordered space; the spaces, in turn, may have to shift to accommodate a leg, or split a head, until a balance is achieved.

JOANNE TURNEY

I feel as if I am the instrument through which the spirit of life can be revealed on canvas. This is a wonderful gift and I treat it with respect. I trust the Divine mind within me to be my leader and guide. It is a feeling of surrender, plus a combination of freedom guided by responsibility. Art has no language barriers which gives me permission to touch the soul in everyone. My desire is to peel away the visible exterior and expose what is beneath – color, texture, energy, spirit, love, light.

Texture is important in my art to portray the energy and strength which emanates from beneath the surface of the subjects I see. Abstraction is the instrument I use to articulate the very spirit of life, as I experience it on my canvasses. I approach my work with feelings of reverence and gratitude, since it is art that provides me with the gift and opportunity to explore the mysteries of life.

My travels through the Middle East, Southeast Asia, Africa, Europe and the United States have had a major impact on my art. It contributed to my understanding of color, design, form, and composition. Art has no language barriers which gives me the permission to touch the soul of everyone.

REGINA NOAKES

Viewing life like an aesthetic experience, many of my canvases are translations of memories and observations. Visions are stored in my mind and reproduced later in my studio. Some images have been saved since childhood. There are stories behind most of the paintings, and drama in the universals of companionship, love, age, and acquiescence. Several of my large-scale figurative paintings have references to myself and to my daughter. A point of focus in some experiences is the Doll, as a repository and reflection of human experiences, sometimes almost human, and more.

There are references to Mughal art (I am of Indian origin) – flat surfaces, strong colors, cloisonné, and also to Romanesque paintings – the iconic work from that period, and also the frequent focus on women.

VALERIE PATTERSON

The truth lies within the inner self – the solitary watcher...

It is said that our personalities become fully formed during our first few years of life. Thus, the fears, hopes and dreams that we experience very early on, I believe, can and do, influence and shape us for a lifetime. Whether or not we are conscious of it, our inner child is always communicating to us. The woman can't help but see aspects of herself in the young girl.

The images on this site came about as a result of a series of ongoing inner dialogues between my adult and child selves. It has been my experience that the very young and very old often possess a higher sense of the spiritual, a deeper understanding of life. I employ their images as powerful symbols of innocence and the human struggle to understand various aspects of our existence.

I believe that it is the artist's job to move the viewer beyond mere aesthetics, to probe beneath the surface of an action, comment, belief, relationship, to expose a piece of its essence, no matter how disturbing or unsettling that it may be.

While each artwork inevitably contains a sense of the personal, I believe that at the same time it is important that it also contain a social or political dimension. By sharing things that I have learned, or struggled with, I seek to create images that will in some way provoke thought, action, and a sense of commonality.

Although my work is often inspired by photography in areas of subject matter and composition, it strives to transcend the commonplace and arrive at an enigmatic and mysterious reality.

ROSLYN ROSE

I was inspired to create my current Assemblages by a desire to honor the histories and myths about women. As I continued to study this theme, I became intrigued with the lives of female artists who had died before their full potential was realized. The "Popova" group of boxes is an example of this interest.

I gather articles and ideas for my mixed media works during my foreign travels, visits to flea markets, and by collecting the castoffs of friends and relatives.

When I start working on a new idea, I am usually inspired by the shape and size of the box itself as well as a theme suggested by mythology or lore. Although I concentrate on the lives of goddesses and women of the past, the finished assemblage usually suggests details of my own history.

DELLAMARIE PARRILLI

My paintings are abstract expressionistic, a synthesis of feelings and ideas that establishes a reality accessible to all. I explore that which comes from and projects itself toward infinity by creating a depth of dimension. Layered brushstrokes, vibrant, sometimes subtle, superimposing images upon images, give the illusion of translucence and immateriality, emphasizing the emergence of interplaying worlds, visual ideas and visions.

I am open and responsive to recurring impulses, integrating poetic content, human values and the senses as I continue to explore emotions through my paintings. My work mirrors my own expressive and conceptual maturity. I am inspired by the realm of the subconscious including the spiritual, combined with a modern approach and preoccupation with psychology and introspection. I am drawn to that which establishes the continuity of existence and drives one toward the truth and totality of experience, engaging the senses while allowing the exploration of the viewer's own reality.

JOAN GIORDANO

These pieces emerge from singular cumulative experiences: the vast expanse of ocean, brilliant moss-green fungus, peeling tree bark, skins, crumbling walls and decay. My journey takes me deep into the earth to some ancient place within myself: inner reality becomes outer form. I am interested in the transformative nature of time – its relationship to materiality and to the evolution of form. Beauty is change.

THE GRANT PROPOSAL

IT PAYS TO APPLY FOR GRANTS

We must never forget that art is not a form of propaganda;
it is a form of truth.
John F. Kennedy

There are a plethora of grants available to artists through foundations, corporations, trusts and government agencies. They range from fellowships, project grants, emergency assistance, public art commissions, education and study grants, residencies and travel grants. Some grants reward the young, emerging artist, while others benefit the mature artist. Some grantors accept submissions year around, while others have very specific deadlines.

A grant is an award. It is not a loan that has to be repaid. It may, however, be subject to income tax. Anyone can apply for a grant as long as they fit the grant-giver's criteria. The more grants you apply for the easier the process becomes. And, the more grants you receive, your chance of acquiring them increases.

Grant amounts range from as little as $25 up to several thousands of dollars. Grants can also include non-cash forms of support including education, equipment, supplies, studio space and exhibitions.

There is a range of uses for grant money. They include emergency conditions, time to work, materials and equipment, exhibitions, commissions, travel, education and more. You may apply for as much money as you possibly can. You may also apply simultaneously for the same funding from many different grantors, as long as they aren't in the same agency.

Your local, state and national organizations will offer direction to help you find the most appropriate resources for your situation. Artists and artist coalitions that have received grants are also valuable sources of information and guidance, since they have already gone through the process of research, formulating ideas, expressing their needs and writing proposals. In addition, non-profit art organizations are good resources since they are constantly involved in the process of fund-raising through grants in order to survive.

There are many books on the subject in addition to magazines and newsletters. Don't ignore the local library for a wealth of information. Among the many valuable websites are www.fdncenter.org, which has libraries in NYC and Washington, DC and www.nyfa.org, which is located in New York, NY. We list grant opportunities in our Artist's Resource section of our website at www.ManhattanArts.com in addition to our bi-monthly publication *Success Now! The Artrepreneur™ Newsletter.*

When you begin the process, you should learn the following facts about the grantor, such as:

- Contact information
- Date of inception
- Overall mission
- Purpose of the particular grant(s)
- Types of grants they fund
- Kinds of support they provide
- Materials they require from the applicant
- Application receiving deadline

WRITING THE GRANT PROPOSAL

Most grantors will require an essay-type of proposal. As a rule, you will be asked to address specific questions about your work, about your commitment to your work, about your development as an artist, about your artistic philosophy and about your goals. The underlying concerns that will be asked directly or indirectly are: Who are you? Why do you want this grant? Why should we grant your request?

Needless to say you must provide a convincing argument. Your proposal contains the introduction, body and conclusion. The introduction essay should state your point or premise and indicate that you are addressing the grantor's requirements and/or questions. You should offer evidence in support of your main point. The conclusion wraps the entire essay together. Discuss how you will bring about your desired objectives. Provide specific activities you will conduct to meet them. Think about your proposal as presenting a problem and its solution. From introduction to conclusion your essay must be factual and coherent.

All of the guidelines that apply to writing business letters, biographies and artist's statements covered previously in this book apply here. Your writing must be clear, concise and free from spelling and grammatical errors. Refer to the section on the artist's statement for tips on getting started and inspired.

Your career history may be a determining factor in the grant-giver's decision-making. It may, therefore, be necessary to enclose a résumé. If a career description is a required field on the application form, make a note there that you have attached a more detailed résumé.

Submit the best possible slides and other visuals you can afford and according to their guidelines. Label them properly. Unless otherwise noted, slides should contain your name, title of work, dimensions (height, width and depth – in that order), the top of the slide and a number corresponding to a separate slide list if requested. Send the exact number of slides called for.

If you are asked for a summary provide a concise statement that expresses what you are seeking funding for. Even if it accompanies a ten-page proposal, the summary may be the only document that is reviewed by the funding committee, so be sure it is direct and to the point. If the proposal exceeds several pages, you should add a table of contents. This makes it quick and easy for the reviewers to obtain the information they need.

If a budget is required you must plan carefully. Explain the costs of materials, studio or exhibition space, equipment purchase or rental and utilities. Don't ignore office supplies and professional services such as postage, printing and photography.

Don't be surprised if additional documentation is required such as IRS information, profit and loss statement and proof for not-for-profit status. Needless to say, you must comply with their requests.

Sometimes critical reviews that have been published in art magazines or catalogues are requested. Other important documents include letters of recommendation from professionals in the field, such as other distinguished artists, curators, professors and critics.

Follow the instructions for how to package your application. If no instructions are provided, use a pocket folder. Save a copy of the completed grant application and proposal for your records.

Be creative in your search for assistance. In addition to the large pools of conventional grantors that are approached nothing should prevent you from seeking monetary help or supplies from friends, relatives, printers, framers, or office supply stores.

QUICK TIPS

- Each individual grantor has their rules and requirements. You must pay attention to their instructions and send them precisely everything they ask for. Avoid adding materials not requested. Failure to follow instructions may cause your application to be discarded.
- Applying for a grant requires time and commitment. Do your homework, be organized and have a system.
- You should make sure you have a good potential match between your needs and the grant organization's needs.
- The application should be neatly typed.
- If at first you don't succeed, try again. If a grantor rejects you, you may reapply at a later time.

CREATING THE BEST VISUAL IMPACT

Success is what sells.

Andy Warhol

DESIGNING YOUR PROMOTIONAL MATERIALS

We can all wish otherwise, but in this highly competitive field talent alone does not suffice. To believe that art has some mysterious power to sell itself is to be overly optimistic. Although many people respond to art viscerally, follow their intuitive responses, and never require the advice of other individuals or sales materials to make a decision to buy art, the majority of individuals rely on expert opinions, in addition to the credentials of the artist. Positive presentation materials reassure buyers that their inclination to buy a particular work of art has been validated.

In most situations your promotional materials have less than one minute to make an impact. You will want to pay close and strict attention to designing them since they will reflect your level of professionalism and commitment to your work. Every detail, including the quality of the paper you use, the type style, the tone of your message and the neatness of the overall package is being judged. If any part of it appears unclear or unkempt, the recipient may lose interest. Whether you are approaching a gallery, applying for a grant or entering a juried competition, you will want to make sure your materials are of the best quality available.

The promotional piece may range from a small business card or postcard with a single image of your work to a brochure or catalogue featuring several pages and images on each page. The piece may be printed on one or two sides. It may be designed as a flat sheet or scored and folded.

The promotional piece is an effective sales tool to announce an exhibition, a new series of work or limited edition print. It is also an effective and convenient tool to distribute by hand when you are networking and building new professional acquaintances.

Depending on your home or office equipment and software, desired results and budget, the piece may be designed and printed from your own personal computer, printed at a quick-copy shop or a commercial printer. There are several commercial printers that specialize in printing artists' promotional materials. *(See the Resource section of the book.)*

There are many benefits to creating printed promotional materials. In the long run, flat materials are less expensive than slides and the package will be lighter and less costly in postage, especially if you are conducting a large quantity direct mail campaign. The promotional piece may be mailed without having to ask for it to be returned, saving you the costs for bulky return envelopes and postage. It is also an easy piece for the recipient to file for future reference. Despite the high costs, a color catalogue often brings prestige to the artist's work, especially if it features an essay or quotes from a museum curator or noted art critic. The expenses for a several-page catalogue can be shared with a corporation, museum, gallery or non-profit exhibition space, although an increasing number of artists are self-publishing.

QUICK TIPS

- Before you begin the project consider the results you hope to receive from your promotional piece and the market you are targeting. Are you going to use the piece to replace a sheet of slides when you approach galleries and corporate art buyers? Do you want it to help you increase private sales or patronage? Are you using it to promote an exhibition or other event? Is it a promotional piece to attract students to your workshop?
- Use the best quality slides, photographs, digital files, or transparencies for reproduction. Use original materials, not duplicate or second-generation materials.
- Select the strongest images that receive the most positive responses.
- Select the paper color, weight and texture that will be compatible with your art and will present your images well.
- Select an easy to read type size and type style.
- Collect many samples for ideas on layout and design as well as the content and tone of the text.
- Ask successful artists and galleries for ideas that have worked for them.
- Unless you are printing a self-mailer, select the size of your envelope and design your brochure to accommodate it. For example, a brochure that is printed on a full sheet of 8 ½" x 11" can be folded into thirds and mailed in a #10 envelope or folded in half to fit a 6" x 9" envelope.
- Check your local post office about their postal codes.

*Good design, like good painting,
cooking, architecture, or whatever you like,
is a manifestation of the capacity
of the human spirit to transcend its limitations.*
George Nelson

- The content of your brochure should be: reproductions of your work, résumé or biography, an artist's statement, critics' quotes, price and exhibition information. It should also contain your name, address, phone and fax numbers, e-mail address and website address.
- The dimensions of the piece should be considered to fit into a file or pocket folder when accompanied with other documents for a gallery presentation package or press kit.
- When conducting a large direct mail campaign, postage is a factor. Select a paper stock that is neither excessively heavy for your needs, nor one that is light weight and perishable.
- The number of copies you need will depend on the size of your mailing list and the date you will be replacing this piece with a new one. Your printing costs per piece will decrease as your print run increases.
- Stress quality, not quantity. Don't crowd the page with too many images or too much text.
- Remember, the purpose of the promotional piece is to introduce your style and subject matter. Your goal is to arouse the viewer's interest in seeing the actual work.
- Successful self-promotion is governed less by finances and more by creativity, communication, clarity and commitment.
- Find your own self-expression and prepare your materials to reflect it.
- Begin your project with a predetermined budget and a strategy.
- Compare different printers in the areas of pricing, quality and production time. Ask artists and galleries for referrals.
- Decide on your required printing turnaround time.
- Be prepared for opportunities to promote yourself. Carry several copies of your promotional materials with you at all times.
- In addition to announcing an exhibition your postcard or folded card may be sold in galleries and shops and used by yourself as note cards and holiday greeting cards.
- If you plan on using it as a self-mailer, save space on one of the outside panels for the mailing address, your return address and a postage stamp.
- Discuss the idea of producing a promotional piece with your gallery. They may offer to pay for part or all of the costs.

SAMPLE OF THE ONE-SIDED BUSINESS CARD

When you print a business card feature an image of your work on it. A business card with a strong, horizontal or vertical image of your work, printed in color or black and white is an excellent form of self-promotion.

To reduce your printing cost, place the image and text on the same side.

SAMPLE OF THE TWO-SIDED BUSINESS CARD

Side one Side two

Cards like these can be created on your personal computer or copy machine. There are many varieties of card stock available. Experiment with different papers, sizes and formats. Check the Resource section in this book for printers that specialize in business cards and postcards.

SAMPLE OF THE ONE-SIDED POSTCARD

I Love Manhattan
June 26 – July 20

Presented by

ManhattanArts
INTERNATIONAL

200 East 72 Street, New York, NY 10021
Tel: 212-472-1660
www.ManhattanArts.com
Open by appointment

Raul Manzano, oil on canvas, one of the Artist
Showcase award winners

This is a sample of a one-sided postcard that can be mailed alone or placed in an envelope. Printing on one side reduces printing costs. You can apply your return address label on the other side or use a rubber stamp.

SAMPLE OF THE TWO-SIDED POSTCARD

I Love Manhattan
June 26 – July 20

Presented by

ManhattanArts

INTERNATIONAL

200 East 72 Street, New York, NY
10021
Tel: 212-472-1660
www.ManhattanArts.com
Open by appointment

Raul Manzano, oil on canvas, one of
the Artist Showcase award winners

Manhattan Arts Intrnational
200 East 72 Street
New York, NY 10021

< Place postage stamp here.

This is a sample of the text side of a two-sided postcard. The image of the art work would be featured on the reverse side. This sample is not the actual size. It has been reduced to fit the page.

< Place address label here.

< Leave ¼ inch on the bottom for the postal bar code strip.

SAMPLE OF THE SELF-MAILER FOLDED CARD

JADE MOEDE

CARICATURE FUN

Inside Top and Bottom

< Fold

< Place biography and/or artist's statement here.

Manhattan Arts International
200 East 72 Street
New York, NY 10021
info@Manhattanarts.com
www.Manhattanarts.com

Outside Top & Bottom
<Here you can place exhibition information, an image of your work or text, such as quotes from a critic.

< Fold
< Place postage stamp here.

< Place address label here.
If you decide to mail this folded card in an envelope you will gain an extra page to place an image or more text.

FRANK BRUNO

Vast Greeters, oil on wood panel, 48" x 48"

Max Helio, mixed media, 30" x 22"

"Frank Bruno captures the celebratory spirit of his subjects in an expressive style with robust color and rhythmic compositions. His paintings exude an infectious energy." – Renée Phillips

Frank Bruno is a graduate of The York Academy of Arts, York, PA and he attended Pratt Institute, Brooklyn, NY. He has won several awards for his work including several from Manhattan Arts International's juried competitions. Bruno has exhibited extensively in New York, NY, Philadelphia, PA, and other cities in the U.S.

**Contact: Frank Bruno, 710 Collegeville Rd., Collegeville, PA 19426.
Tel: 610-489-4213. E-mail: frank-bruno@comcast.net**

SAMPLE OF THE TRI-FOLD BROCHURE BY JADE MOEDE

Side 1

Jade Moede
Oil Paintings

STOGIE TAKE MY BREATH AWAY 7"X 5"

"Jade Moede is a serious artist with fine technique and a sense of humor which is sometimes obvious and often subtle. His hidden punch line borders on surrealism. The events taking place or about to take place go beyond their picture frame. They intrigue and capture one's imagination with the ability to give just enough. Jade's point of view is very appealing."
Anthony Palumbo
Artist and instructor at the Art Students League, NY.

GARLIC 7"X 5"

Jade Moede
24 Elm Street
Rutherford, NJ 07070
201-896-0402

Jade Moede
Oil Paintings

MEO2 (Detail) 7"X 5"

www.jadepaint.com

Side 2

"The paintings of Jade Moede are engaging and enigmatic. His technical prowess is heightened by his ability to bring a unique perspective to otherwise ordinary subjects."
Renee Phillips
Author and member of the
International Association of Art Critics

EGG ON BOARD WITH FEATHER 5"X 7"

Jade Moede
Oil Paintings

Artist Statement

To paint a time in space that stands still. A melody of a vision of an interpretation. The painting becomes a passage that plays on.

Jade Moede

Jade Moede (pronounced Maydee) is an award-winning artist currently living in Rutherford, NJ. His painting "Life's Choices" won second place in the Animal Art Category for the "Artists Magazine 2002 Art Competition" and was featured in their December 2002 issue. He is also the recipient of the DaVinci Paint award presented by the Rutherford Art Association. Among his exhibitions was a one-person show titled "STILL Jade" at the Kortman Gallery, IL. He has shown his work at the Art Students Showcase gallery, NY and the Manhattan Arts International gallery, NY. His work was selected to be featured on their website at www.ManhattanArts.com.

Jade's paintings are held in many private collections throughout the U.S. and he has been commissioned to create a range of paintings and drawings of still life, landscapes, and portraits including those of animals.

The artist studied painting under Gregg Hildebrant and drawing under Ben Ruiz. He graduated from the Kubert School of Cartoon and Graphic Art, NJ. He furthered his fine art education at the Art Students League, NY where he served as class monitor for the renowned artist Anthony Palumbo, also was monitor for the ecorché class taught by the legendary anatomist Frank Porcu. He has also studied painting privately with the master artist Wade Schuman.

THE GALLERY PRESENTATION PACKAGE

*The gallery interviews up to 50 artist applicants
in person and receives about 20 parcels
of slides and photos in the mail each week,
and visits the studios of those
it considers to have works worthy of close inspection.*
Ivan Karp, O.K. Harris Works of Art

Preparing the gallery presentation package is one of the first and most important steps in acquiring gallery representation. Although regional galleries may accept artists who walk in with their works in person, most galleries require a more formal introduction and will want to see presentation materials first. If your materials produce a positive response, the dealer may invite you to bring in samples of your work or may visit your studio. Needless to say, your presentation package must be prepared in an organized, professional manner with excellent quality visual images.

Before you invest time and money, make sure your work is appropriate for the gallery you are approaching. Determine the gallery's aesthetic direction, style, philosophy and professional requirements. When you are ready to submit your materials send images that reflect a consistent development of your artistic vision. The same procedure is applicable for sending materials to corporate art consultants.

Before you approach the gallery of your choice find out the desired times they review new artists' materials. This information about New York galleries is available in our book *The Complete Guide To New York Art Galleries,* a comprehensive resource that contains detailed profiles of more than 1,000 galleries and exhibition venues. Another question we ask of them is: "What materials do you want artists to submit?" In most instances the response is "slides or photographs, biography, résumé and S.A.S.E.."

Traditionally, a sheet of slides has provided a purpose. Containing up to 20 different images, a slide sheet gives the experienced viewer a good idea of the artist's direction and breadth. When your package arrives at the gallery most dealers (or the assistant director or intern in the gallery) will take a quick look at your slides with the aid of a light box, loop, view finder, lighting fixture or sunlight to determine their level of interest. Seasoned dealers and curators know how to read slides and envision the work in its actual size.

We look at new artists' slides almost every Thursday.
Artists should leave slides in the gallery for review
and pick them up later that day.
Nancy Hoffman gallery

If the gallery specifically requests slides, by all means submit them. Arrange them neatly in a new, clean acetate slide sheet. Any number from 10-20 slides will suffice. A Slide / Price List should accompany your slides. The list should be typed on your letterhead and should include the same information as provided on the slide label: your name; title of your work (titles should be italicized or underlined); medium; date of completion; and dimensions. For three-dimensional works: height x width x depth; two-dimensional works: height x width. In the U.S. measurements are provided in feet and inches.

Outside the U.S. the metric system is normally used. Both are acceptable. To convert centimeters to inches: 1 in. = 2.54 centimeters (cm.). You may also provide additional information such as if the work is part of an important collection, a site-specific piece, public commission, etc.

Don't assume the individual who is viewing the slide will know the front, back, top and bottom of the image. A red dot should be placed in the lower left hand corner of the front side (when it is in the correct position for hand held viewing.) This also instructs the person placing slides in a slide tray the correct position for projection. Also acceptable is to place an arrow in the upper right hand corner of the front side indicating the top of the slide. If space allows, write the words "Top" and "Front" on the slide.

Enough said about slides. The question is, do you want your work to be judged upon an image that is a fraction of the actual size? *Of course not!*

My advice is to send the gallery an impressive presentation package. If you want to stand out from the rest of the applicants select the reproduction method that will most effectively and accurately depict your work. I have been advising artists to create a book that includes 8" x 10" color photographs, laser or color Xerox copies, or full page promotional sheets. If you are skilled in Photoshop you can create very accurate reproductions. Add the descriptive text below the image (title, medium and dimensions). This may require that you run the paper through the printer again in order to add the text. If you cannot do it yourself, many walk-in print shops, such as Kinko's can do the job for you. There are numerous graphic designers who specialize in creating promotional materials for artists. *(See the Resource section of this book.)*

You may want to place a color image on the cover of the folder. An easy method to accomplish this is to print your image on an adhesive label. Avery labels make a full sheet size. If you are looking for the same quality at a lower price try Quill brand 8-1/2" x 11" adhesive label sheets. (1-800-789-1331 or www.Quill.com.) Additionally, you can use a spray adhesive on the back of your color print.

Whether you submit 35mm slides, 4" x 5" or 8" x10" transparencies or color prints submit professional quality images: If your visuals fail, so will you. Unless you are capable of taking professional quality work yourself, seek the best photographer around that specializes in art photography. Ask for referrals from artists, galleries and museums whose visuals meet your satisfaction. If you want to learn how to photograph your artwork, there are many excellent books available on the subject, some of which are listed in the Resource section of this book.

High quality brochures or catalogues that feature several reproductions of your work, a brief biography and artist's statement are quickly replacing the need for slides for the purpose of the initial introduction. To complete your presentation, add a cover letter, résumés, copies of reviews and articles or excerpts of the best ones. *(Refer to the individual sections in this book for advice and samples of each.)*

If you want your materials returned, enclose a S.A.S.E. with the proper amount of postage. Indicate in the letter which materials the receiver can keep. Add materials they can keep on file and not have to return.

A growing practice is for artists to submit a video tape or a CD-ROM. It is space-efficient and eliminates some of the steps and costs involved in printing promotional pieces since you can fit 100 slides onto one CD-ROM that weighs about 3 ½ ounces. Once your images are on disc you can send them to galleries, publishers, agents, architects, interior designers, arts organizations and buyers across the continents – within minutes. No papers and S.A.S.E. to stuff inside envelopes, and no printing and postage costs.

We have learned that although many other professionals readily accept this format galleries still prefer to view flat materials. If you add the CD to your presentation book make sure the format is compatible to both Mac and PC users and is easy to navigate.

Artists will be required to submit slides and/or photographs,
résumé, and a site-specific proposal.
Marilyn Karp and Ruth Newman,
Washington Square East Gallery, NYU

QUICK TIPS

- Never submit inferior slides, photographs or other visual materials to galleries. Spend time preparing the best possible presentation materials.
- Don't send galleries unsolicited jpegs to galleries unless that is their policy.
- View several exhibitions in the galleries in person to determine if your work fits their criteria before submitting your materials.
- Ask respected members of the art community about the reputation of the gallery.

- Speak to the personnel, attend the opening receptions, and network with members of the art community.
- Develop relationships with artists already represented in galleries. Dealers often rely on their artists for recommendations of other artists.
- If you cannot travel to see the galleries visit their websites, and read the reviews in the art publications.
- Send the materials to the specific person in charge and enclose a cover letter.
- Enclose an S.A.S.E. if you want your materials returned.
- Enclose materials they can keep on file.
- After you send your materials, give the relationship time to grow. Exercise gentle persistence and patience.
- Unless you receive a firm rejection, keep in touch through routine visits to the gallery and the mail.

When you are in New York City, please attend Renée Phillips's workshop "How to Sell Your Art" (also known as "How to Break Into New York Art Galleries"). It is a comprehensive course presented monthly that teaches you how, when and where to approach to exhibit your work in NYC.

Ms. Phillips presents workshops like this for arts organizations throughout the U.S. Please inquire about how to arrange such a workshop.

Manhattan Arts International is comprised of a network of Artrepreneurs™ that offers critiques on your presentation materials plus graphic design, editing and other services to help you prepare the best materials possible. Please contact us for additional information. Call 212-472-1660 or visit www.ManhattanArts.com.

RAISING THE VOLUME ON SELF-PROMOTION

In the future everyone will be famous for fifteen minutes.

Andy Warhol

Publicity is free exposure from members of the press – in the form of print, radio, TV or the Internet. There is a direct correlation between the power of the press and your professional status. The more known you are, the more value is accredited to your work and the more influence you gain. If you want to increase your fame and fortune raise the volume on self-promotion.

Positive publicity adds credibility to your professional reputation. As your reputation grows, so does the commitment from those individuals who already support you and your work, in addition to attracting new followers. You gain the attention of galleries, collectors, grant-givers and critics. Once the momentum gets going you'll notice that publicity attracts publicity. Writers find new story ideas by reading articles, watching television, listening to radio and exchanging ideas with other professionals.

As a member of the International Association of Art Critics and Editor-in-Chief of *Manhattan Arts International* for more than 17 years, I have observed that most materials from individual artists, arts organizations and non-profit associations are either noticeably absent, arrive after the editorial deadline, are incomplete or are poorly prepared. When artists complain that the press ignores unknown artists, to a large extent their complaints are justified. The reasons are not all dealers promote emerging artists adequately and not all artists know how to perform the basic steps of publicity. The publicity savvy art dealers, non-profit organizations and professional publicists are the ones succeeding in getting attention.

To begin the process, you will need to invest in postage, envelopes, letterhead and good quality visual reproductions of your work. Having an answering machine, fax machine and computer will increase efficiency. You will need to produce a cover letter, press release and good visuals.

Whether you exhibit in commercial galleries or alternative spaces you will probably be required to share the responsibility for promoting your exhibitions. It is time-consuming indeed; however, the artist who creates something worth publicizing, plans strategies in advance, and develops on-going relationships with members of the press – before, during and in-between exhibitions – is richly rewarded.

I once assisted an artist with his exhibition in a library in the suburbs of NY. We called all members of the press in his area and supplied them with excellent photographs. To our delight, a major art editor at *Newsday* selected the photograph and ran a large image of it in the centerfold of the weekend Arts section. Other regional papers followed suit. He had more attendance at the reception than he could handle. Many artists would say, "Why bother – it's only a library exhibit." We didn't and we were glad we made the effort.

BUILDING YOUR RELATIONSHIP WITH MEMBERS OF THE PRESS

There's only one thing in the world worse than being talked about,
and that is not being talked about.
Oscar Wilde

Before approaching the press, make sure you are familiar with their particular editorial framework, point of view, topics and deadlines. Call to verify the proper contact person. You may call to notify them that a package is being sent to their attention and ask how they would like to receive it – by mail, fax or e-mail. Your story idea can often be pitched successfully over the phone, so develop a strong verbal introduction that will engage their interest about the materials being sent. Be respectful, assertive (not pushy), succinct and enthusiastic.

Editors receive hundreds of press packages daily through mail, fax and e-mail. When they make their selections for publication it is often the packages that are newsworthy with good visuals that make it to press. They want essential information at their fingertips. If they have to search for it in the press release, time is wasted and the materials often go into the wastebasket.

Give them news they can use. They receive many ideas for stories every day, so look for a good "hook" that will grab their attention. What about you would be of interest to their audience? What is it about your exhibition, award, special commission, or your overall professional history or personal life that is of news value? Is your work related to current events? Would the motivation behind your new work be inspiring to others? Have you developed a new art form using modern technology? Do you have a new and unique website?

Examples of attention-getting events are: an artist unveils a commissioned sculpture in a national park; an artist's exhibition benefits a children's charity; a postal worker retires at age 65 to become a full-time painter; and a panel discussion debates the current state of the Arts.

When you make the initial phone call keep in mind these people receive stacks of materials and dozens of e-mail daily. They are often under the pressure of a deadline. Before you begin to pitch your story ask if they are under deadline. If so, would they prefer you call back at a more convenient time?

Managing your press list will be an on-going project that will require maintenance, cleaning and editing. Start locally. Contact the newspapers, magazines, art periodicals, and TV and radio stations. Ask them for the names of the arts writers, feature writers, editors and people who handle the calendar or events listings. Ask for their deadlines and an editorial calendar. Check out their websites to become more acquainted with their style and subjects of interest.

Be organized: Keep an up-to-date mailing list of members of the press and a record of your efforts. Do your research: Make frequent visits to well-stocked magazine stores and libraries to keep abreast of the new and ever-changing editorial developments in the world of print publications. Access the Internet for leads. Determine your appropriate venues. Maintain an "Ideas and Leads" file of interesting articles and note the name of the publication and date the article appeared.

Send materials in time to meet deadlines. The rule of thumb is: 2-3 months ahead for monthly, bi-monthly and quarterly publications; 2-3 weeks in advance for weeklies; and 1-2 two weeks for dailies. Radio and TV: two weeks. Remember this is a general guideline. Contact each publication directly to find out their exact deadlines, in addition to what materials they prefer and in what form. It is a good idea to insert a return, postage-paid postcard with a few simple questions that will help you with future mailings. *(See a sample in this section.)*

Follow up 7-10 days after you mail your materials to confirm that they arrived. Your calls will also lead to gaining more insight, such as information about future topics and changes in editorial direction, as well as another department or editor to approach. Your phone call might go something like this: "Hello, my name is John Smith. I'm calling to follow up on information I sent to you about my exhibition titled "Manhattan Rhythm" at Blue Gallery. I was wondering if you received it and if you will be using the information or need any additional materials." Fax another press release during the week of the event as a last minute reminder.

PUBLICITY OUTLETS

- Regional, national and international art publications.
- Regional and national newspapers.
- Daily metropolitan newspapers.
- Free weekly community newspapers.
- Art and culture related newspapers.
- General interest magazines, such as *Newsweek*.
- Special interest magazines with targeted audiences, such as those emphasizing Fashion, Travel, Collecting, Hobbies, Pets, etc.
- City magazines, such as *New York* magazine.
- Foreign language publications, foreign radio and TV programs.
- Art organization newsletters, alumni publications, other organizations' periodicals.
- Wire services, such as Associated Press and United Press International.
- Electronic Media: Radio and television.
- Online publications and other websites.

QUICK TIPS

- Start by becoming a big fish in a small pond.
- Set regional, national and international publicity goals.
- Create high quality, professional materials that will reflect your work in the best manner.
- Become active in the art community. This will attract attention.
- Give them news they can use.
- Meet the deadlines!
- Help writers with other newsworthy information in your field of interest. They will come to rely on you for ideas and leads.
- Ask the publication for "Writer's Guidelines" and "Editorial Calendars."
- Get to know critics by entering competitions that are juried by them and put them on your mailing list.
- Invite art critics to participate in panel discussions sponsored by your organization.
- Volunteer to work on the publicity committee of your arts organization.
- Don't limit your publicity approach solely to the fine art writers. There are many opportunities in hundreds of columns – from style and hobbies to travel and food.
- Establish relationships with freelance writers who write for several publications.
- Don't underestimate the value of writers with small, regional publications. They are more accessible and their audience is comprised of many prospective collectors of your work who live and work locally.
- After you receive publicity send the writer a letter of thanks by mail or e-mail.

- Stimulate interest about yourself and your work by creating a solid art foundation and spread the word about your accomplishments in the form of news releases and press kits.
- Get to know the up-and-coming new writers and climb the ladder together.
- Continue to send releases to top critics as well as smaller publications. You shouldn't expect immediate response from them but if you are newsworthy and persistent eventually they will become familiar with you and your work.
- Talk and write about your work with confidence and enthusiasm. Let others spread the word.
- Plan your event at convenient times for news professionals. Also, check the calendar before choosing the date to make sure the time does not conflict with a major event.
- Keep your eyes open for new publications, new online magazines, new websites, new general, business and trade magazines and talk shows, new jobs and titles of editors, new beats and features.
- Keep abreast of new tools being used to reach members of the press, such as press kits on video and CDs, and the invaluable use of the Internet.
- Address your envelope by hand if you want your material to stand out among the rest.
- Unless they specifically requested expensive irreplaceable materials don't bother the press by asking for your unsolicited materials to be returned.
- Record your publicity efforts on a progress report, and persevere.

ADVICE FROM P.R. PROS

The highest reward for one's toil is not what one gets for it
but what one becomes by it.
John Ruskin

ADVICE FROM CAROLE SORELL and JOHN ROSS

Established in 1980, Carole Sorell Incorporated is a public relations firm located in New York, NY, that specializes in the promotion and marketing of the arts and culture. Its principles Carole Sorell and John Ross have extensive experience working with museums, galleries and artists.

When asked for tips based on their public relations experience, Carole and John suggested:

- Anything that falls in the art world is considered soft news by members of the press. There is no reason to write about it unless it is interesting in some way.
- All you can do is present yourself truthfully. If you can, think of an angle that would be useful.

- If you have come up with an unusual idea or concept, you will have a better chance to have it published.
- Think about what you are publicizing from a journalist's point of view, rather than your own.
- Remember, working with the press requires patience. Many people are contacting them – don't despair.
- Present your material in a straight-forward manner. Tact and delicacy is important. Pestering doesn't work and it can alienate members of the press.
- If you can swing it – hiring a professional public relations consultant with a background in the arts is a good idea.

ADVICE FROM CORNELIA SECKEL, PUBLISHER, *ART TIMES*

Cornelia Seckel is publisher of *Art Times*, a publication founded in 1984 that serves the cultural corridor of the Northeast and provides commentary and resources for all the arts. When asked to provide some advice about getting the attention of members of the press, Cornelia said: "There are several critical things to keep in mind when approaching them." Among them are:

- Know the Publications/Media – their purpose and needs. This means read several issues / listen to broadcasts/view programs.
- Find out who the people are that you should be contacting – spelling does count! Ask directly how and when they want information, what specifically they want (statement, pictures, calendar information, etc.), and how the information should be sent –e-mail, by regular mail – rarely will someone take information over the phone.
- Have your tools prepared: Photographs of your work, photograph of you in your studio, artist's statement and brief biography.
- Be genuine, have patience and know whom you're dealing with.

ADVICE FROM JANET APPEL

Janet Appel is President of Janet Appel Public Relations, in New York, NY, and also works as a freelance publicist. She has worked with arts organizations, as well as handled financial, equine, entertainment and fashion related clients. Her advice is:

- The most important step in handling your own P.R. is to determine the angles that you will use to attract the attention of the press. There are usually several ideas that can be generated to create a buzz about the work, or the artist who created it, or perhaps even the location in which it was created, or any other number of possible combinations. Write a couple of press releases – each one focused on a different angle. Have them ready to send out after speaking with the editor or writer.

- Rehearse your pitch and make sure you can present what you have to say in a clear, concise manner. Be prepared to switch your game plan if your pitch is rejected. Have that second angle ready to discuss, immediately.
- It is important to find the outlets, and the person who will relate to your particular angle(s). There are often several editors or writers to approach, rather than just one, particularly on a large publication. Send your press material right after you have spoken to the member of the press or media.
- Follow up. This is a crucial factor. Do not assume that the person received the material. Call and make sure that they have received it.
- Aside from the art world press, there may be others depending on the subject matter of what you do, that your work relates to. Think creatively about where you might get a write up. For example, if you paint flowers, contact the horticultural non-profit organizations. They will have newsletters that might consider doing an article or having an exhibition of your work. They might even have a website where they would feature your work.
- Go to some of the smaller publications that are local, for example, where you grew up, your college newspaper, and the alumni association. There are many different outlets that might just be interested in what you are doing because of a past or current relationship.
- Think in terms outside the box, where you or your work may still relate to the publication. It takes time and creative thinking to obtain publicity, and for those who think creatively, the chances are greater.

EDWARD RUBIN, ARTS WRITER SAYS "A PICTURE IS WORTH A THOUSAND WORDS"

Edward Rubin has been a writer for over 30 years. His articles have appeared in the *ARTnews, New Art Examiner, Manhattan Arts International, New York Arts,* and *Theatre Week.* His advice is: "Artists should send a color reproduction of their work with the press release. I want to get a visual idea of what the art looks like when I receive a press release."

Most writers will agree that artists with good photography get much more attention in the press. When a photo, feature, or listings editor looks for artists to include in a magazine or newspaper, strong visuals are selected over poor ones, even if the art is the same quality. Good reproduction quality is of importance.

Action photographs also grab attention: Whether it's of you carving marble, or climbing the mountain to get the perfect photograph, or conducting an art therapy workshop in a hospice.

You must supply a caption with the photograph, either printed on the photographic paper, on a label or as a separate sheet of paper attached with adhesive tape to the back of the photo. If it is a photograph of people list their names in the order in which they are seen in the photograph, from left to right. Write your name, address and telephone number on the back of the photograph in case it gets separated from your other materials.

THE PRESS KIT

The press kit is an organized and informative package of the materials that might be of interest to the press. It is usually assembled neatly in a pocket folder with a color image on the cover. It is distributed to members of the press before a special event, as well as at the event. It may also be mailed after the event to those who did not attend. The package should be easy to follow, comprehensive and save the recipient's time.

Contents:

- Cover letter *(Refer to the section on Writing it Right.)*
- Press release *(Samples are provided in this section.)*
- Fact sheet *(Samples are provided in this section.)*
- Artist's Statement *(Refer to the section on Writing it Right.)*
- Biography and/or Résumé: *(Refer to the chapter on Writing it Right.)*
- Visuals: Photos, slides, or laser prints. Show announcements, post cards, brochures and/or catalogues. *(Refer to the section on The Visual Impact.)*
- Press Clips *(Samples are provided in this section.)*
- Testimonial / Comment Page *(Samples are provided in this section.)*

THE PRESS RELEASE

The press release (also called a news release) is an announcement of an event or a newsworthy item. It is sent to any member of press or media – publications, radio, television and websites. You may send a press release anytime you have or will have something of news value. When you receive an award, grant, fellowship, commission or new title; to announce an upcoming solo or group exhibition; when you produce a new limited edition print; or when you present a lecture or demonstration.

Press releases are generally produced before the event takes place to allow the writer time to announce it in timely fashion. However, a press release can also be issued *after* the event has occurred, if it contains sufficient story value. There is always a chance that the publication will be interested in doing a follow-up story or incorporating your event with other related stories. The press release may also pique their interest in writing a feature story about you.

Make sure your press release includes the following information: your name or another contact name; phone number (make sure you have an answering service); e-mail and website; an offer to arrange a phone or in-person interview; a photograph of your work and a photograph of yourself; and an offer to send additional photographs if needed.

A shorter and concise version of a press release is a fact sheet or media alert. It presents, in a listing format, the "Who", "What", "When", "Where" and "Why." It is often used to supply events editors and calendar listings editors with the quick facts. A fact sheet may be combined on the same page as a press release or become part of the cover letter. *(See samples in this section.)*

QUICK TIPS

- Use good quality letterhead, in a neutral color.
- Type in 1 ½ or double space. Type neatly and use an easy-to-read type size and style.
- Try to limit to one page; if you exceed one page then staple pages together.
- Write it in the third person ("she" or "he"). This is not an artist's statement.
- Be concise. Make sure the reader can read your purpose quickly.
- Write it right! It may be printed verbatim. Obtain editorial assistance if necessary.
- When possible, use the letterhead of the gallery, museum, or sponsor of the exhibition, organization or grant-giver. If so, include at a paragraph about the sponsor.
- At the top of the page write FOR IMMEDIATE RELEASE.
- If the event will include something unusual or the presence of a celebrity or controversial guest add the words "PHOTO OPPORTUNITY."
- Place the contact person and telephone number at the top of the press release. This should be someone who is available during office hours or has an answering machine or service.
- Include the vital information in the headline. Center the headline. Use capital letters. Make the headline direct, concise, descriptive and as interesting and catchy as possible.
- Answer the "who" – your name and business name; "what" – a description of the event; "when" – exact day of the week, date, month, year and time; "where" – exact address, city, state, zip, telephone and if necessary directions; "why" and "how" – the significance of the event. Include these in the first and second paragraphs. Busy editors will look there first and if it doesn't grab them they won't read further.
- Announce the "hook" or the "handle" in the subject that you are announcing.
- Describe the event or the art to give the best visual picture. Briefly describe the scale, color, materials, textures, style and motivation. The materials, point of view, scale, subject matter, or idea may spark interest.
- Refer to any major awards or honors that you recently received or will soon receive.
- Refer to any positive quotes received from critics, historians, writers or other authoritative art professionals.
- Feature a black and white or color image of your artwork on the page of the press release.
- Include a short biography highlighting your important credentials.
- Send press releases or fact sheets to "Listing Editors" and "Calendar of Events" in addition to other editors.

SAMPLE OF THE PRESS RESPONSE CARD

Insert this return postcard with your press materials.

Side A

Manhattan Arts International
200 East 72nd Street, Suite 26-L
New York, NY 10021

Postage

Your Name
Your Address
City, State Zip Code

(leave a ¼" margin on the bottom for postal bar codes.)

Side B

Dear Alexander Shaw,

We would like to provide press materials to you according to your specifications.
Please take a few seconds to fill out this response card and mail it back to us.
We appreciate your time.

	Fax	E-mail	Mail
In what format do you prefer to receive releases?	☐	☐	☐

If E-mail, what is your address?_____

	Yes	No
Do you accept jpegs?	☐	☐
Do you plan to use this release?	☐	☐
Would you like copy provided on diskette?	☐	☐
Would you like to see more releases like this?	☐	☐

Comments: _____

SAMPLE OF THE PRESS RELEASE

B A R B A R A M A T H E S G A L L E R Y

FOR IMMEDIATE RELEASE

Artist's work

Artist's work

Karin Kneffel: Recent Paintings

October 23 – November 27, 2004
Opening Reception: Saturday, October 23, 4 – 6 pm

Barbara Mathes Gallery is pleased to present recent oil paintings by Karin Kneffel in an exhibition that marks the artist's first solo show in the United States.

Known for her innovative realist renditions of interiors, domestic animals, landscapes, and still lifes, Kneffel depicts her subject matter with a strong devotion to precision and a sense of surrealist detachment. Though employing classic techniques and favoring some of the more established genres of realist art, Kneffel does not fail to give her work a definite contemporary twist.

Unusual perspectives, mysterious light conditions, dramatic foreshortening, and the exaggeration of natural proportions provide simple every day objects with an original independence. In lusciously painted depictions of an opened eggshell set against a vivid tile pattern, a West Highland Terrier visually absorbed by a white rug, or spilled water on a parquet floor, Kneffel grants the ordinary center stage and invites the viewer to re-examine the often overlooked.

A former master student of Gerhard Richter, Karin Kneffel studied at the Staatliche Kunstakademie Düsseldorf between 1981 and 1987. She has exhibited extensively in museums and galleries throughout Europe. She is represented in many distinguished public and private collections and has received various honors and awards, including the Karl-Schmidt-Rottluff scholarship (1993), Lingener Kunstpreis (1994), and Villa Massimo, Rome (1996). She lives and works in Düsseldorf.

For further questions please contact the gallery at 212-752-5135.

SAMPLE OF THE PRESS RELEASE

BERNARDUCCI.MEISEL.GALLERY

FOR IMMEDIATE RELEASE

PATRICK S. GORDON
NEW YORK PAINTINGS

2-30 October 2004

Frank Bernarducci and Louis K. Meisel are pleased to announce the solo exhibition of Patrick S. Gordon entitled, *New York Paintings.*

Known as a precision watercolorist for the past twenty years, this exhibition of large-scale still lifes marks the artist's first efforts in oil paint and are arguably his finest works. The *New York Paintings* introduce new characters to Gordon's work, most notably the ubiquitous lipsticks standing sentinel in several of the paintings. Like all of Gordon's subjects, these serve as metaphors in a personal narrative, but they also call up a complex collection of associations for the viewer. Both sensual and sextual, with their creamy contents encased in hard metal, they convey simultaneously, fragility and machined precision.

Gordon's paintings begin as still life, but stretch the parameters of the genre beyond the conventional, investing it with elements of portraiture and story telling. The opulence of his compositions pays homage to the dazzling contrasts in texture and surface in 17th century Dutch painting, while also recalling the narrative threads of *Vanitas* subjects. This influence is directly acknowledged in *Marriage of Arnolfini,* which references to Van Eyeck's famous work in the reflective sphere in which one catches a glimpse of the artist.

Gordon's selection and combination of ordinary objects transform them into lush visual feasts. His titles, full of puns, personal jokes and obscure references, often provide clues to the subtext, while simultaneously suggesting his wariness of taking anything, including himself, too seriously.

Beginning his formal artistic training in the 1970's, he enrolled at the University of Tulsa where he studied under the renowned watercolorist Glenn Godsey. Gordon's art, though shaped in part by abstract expressionism and minimalist aesthetic that once dominated academic art, has never wavered from the realist idiom.

For further information or a color catalog documenting the exhibition please contact Frank Bernarducci or Jane Monti at 212.593.3757. Viewing hours are Tuesday through Saturday 10:00 to 5:30.

SAMPLE OF THE PRESS RELEASE

For Immediate Release
September 17, 2002
Contact: Grant Lindsey, Tel. (212) 343-0290

Works by Alex Grey at Tibet House U.S.
From September 19 to January 3

The astonishing and unique visionary art of ALEX GREY will be on display at Tibet House U.S. from Thursday, September 19, 2002 through Friday, January 3, 2003. Tibet House will hold an Opening for the exhibition on Thursday, September 19 from 6 – 8 PM.

"Grey's paintings, as detailed and anatomically accurate as medical illustrations, present man as an archetypal being struggling toward cosmic sanity," wrote *The New York Times*. "Grey's vision of a flawed but perfectible mankind stands as an antidote to the cynicism and spiritual malaise prevalent in much contemporary art."

Grey's paintings, which have been on the covers of *Newsweek* magazine as well as the Discovery Channel, have been exhibited throughout the world. They are also in such books as "Sacred Mirrors: The Visionary Art of Alex Grey," "Transfigurations," and the artist's philosophical text, "The Mission of Art." In addition, Grey, with Allan Hunt Badiner, edited the recently published book, "Zig Zag Zen: Buddhism and Psychedlics."

Grey, best known for his paintings of glowing anatomical human bodies, seeks to create images that reveal the multiple layers of reality and depict the integration of body, mind and spirit. "It is only Grey's inquisitiveness, his desire to understand the cosmic metastructure of humanity that drives him to such a rigorously detailed account of the typically unseen," wrote *Artforum*.

Paintings on exhibition will include "Nature of the Mind," "Dalai Lama," "Collective Vision," "Vision Crystal," "Void/Clear Light," "Avalokitesvara," "Body/Mind as a Visionary Field of Energy" and "Universal Mind Lattice."

Donald Kuspit, art history and philosophy professor at State University of New York at Stony Brook, wrote, "Grey's pictures serve the cause of religious enlightenment. They are therapeutic in intention, like religion at its best... It is the light that is sublime in Grey's oeuvre – which is the most important innovation in religious light since the Baroque (perhaps the last art to emphasize the sacredness of light, as well as its function as an emblem of the spiritual.)"

Tibet House U.S. is located at 22 West 15th Street in Chelsea and is open Monday thru Friday from noon to 5 PM. For more information, contact Tibet House at (212) 807-0563.

- end -

SAMPLE OF THE PRESS RELEASE

Salander-O'Reilly Galleries, LLC
20 East 79 Street New York, NY 10021 Tel (212) 879-6606 Fax (212) 744-0655

ARTHUR CARTER
RECENT SCULPTURE

FOR IMMEDIATE RELEASE *October 1-26ᵗʰ, 2002*

New York: Salander-O'Reilly Galleries announces an exhibition of recent sculpture by Arthur Carter. The show opens to the public on Tuesday, October 1ˢᵗ. On view will be a number of abstract sculptures in bronze, painted stainless steel and unpainted stainless steel. There will also be studies for constructions.

Arthur Carter is well-known as an investment banker and publisher, and is gaining recognition for his work as a sculptor. His sculpture has been shown at Salander-O'Reilly Galleries and Galerie Piltzer in Paris. Recent commissioned sculptures are installed in front of 90 Park Avenue and in the lobby of 300 Park Avenue in New York. Another has been recently installed on the campus of George Washington University in Washington, D.C.

In the catalogue for the new exhibition, Hilton Kramer notes:

> "In much of Arthur Carter's new work, with its shifting dialogue between the curvilinear and the geometric, the resulting structures often strike one not so much as drawing in space as calligraphy in space – or even ideograms in space. Their cursive, headlong occupation of a circumambient space has something of the gestural quality of fine calligraphy – a 'scribble in the air' aspiring to the monumental. And if at times we are reminded of something more traditional in Carter's sculpture – as I am reminded of Brancusi's <u>The Kiss</u> whenever I see <u>The Couple</u> (1999), his monumental outdoor construction of polished stainless steel and bronze at 90 Park Avenue in Manhattan, that too is a part of its resonance and charm."

Arthur Carter received an A.B. in French Literature from Brown University and an M.B.A. in Finance from the Amos Tuck School at Dartmouth College. In 1981, after a 25-year investment banking career, Mr. Carter founded the *Litchfield County Times* and six years later the *New York Observer*. In 1990 and 1991 he was adjunct Professor of Philosophy at New York University and is presently adjunct Professor of Journalism at New York University. This is Arthur Carter's second solo show at Salander-O'Reilly Galleries.

Also on view LENNART ANDERSON: PAINTINGS Gallery Hours: Monday- Saturday 9:30-5:30

SAMPLE OF THE PRESS RELEASE

FOR IMMEDIATE RELEASE:

HEADACHES ARE ON DISPLAY
FOR PUBLIC VIEWING

PILL HEAD by Olea Nova,
mixed media on paper, 24"x18"

Where Chicago School of Professional Psychology
Dearborn Station Building
47 W. Polk Street, 2nd floor, Chicago, IL

When May 17 - June 28, 2002

On Friday, May 17, at 6:00 pm and again at 7:00 pm, the faculty from Expressive and Creative Arts will comment on the psychological aspects of the artwork.

"Piercing Conflict," a series of artworks, is a story about pain from people who experience it.

Taking the challenge to create such a type of art, artist Olea Nova started with the stories of real people from the opposite sides of the globe struggling with the intense pain of migraines and other forms of headaches. Definition for the artwork was gathered through intense research and then the essence of pain was drawn from the descriptions of symptoms. Feelings and visualizations of suffering people were translated into visual language.

Men and women who saw the artwork commented that it reminds them about their pain. They see themselves in the images and very often exclaim with a smile, "That looks like me two days ago!" Some may say that people don't want to be reminded about their pain.

Others seeing this type of art may gain a positive knowledge that they are not alone in suffering. And they may have an opportunity to smile.

For further information please contact Olea Nova at (608) 782-1112, olenova@hotmail.com.
Janet M. Devlin, Curator, Chicago School of Professional Psychology, may be reached at (312) 786-9443.

SAMPLE OF THE FACT SHEET

STEUBEN

667 Madison Avenue
New York, New York 10021
212 752-1441 tel

<u>CONTACT:</u> Brian Devenny (briand@lhammond.com)
Elizabeth Sawyer (elizabethas@lhammond.com)
212-891-0230 / 0206
LOU HAMMOND & ASSOCIATES
Visit www.louhammond.com 24/7

THE CORNING GALLERY AT STEUBEN

Fact Sheet

LOCATION **The Corning Gallery at Steuben** is located in New York City at the Steuben flagship store, 667 Madison Avenue, at 61st Street, on the lower level. The 2,500-square-foot space is incorporated into the Steuben store, designed by Ralph Appelbaum Associates. The gallery, which opened in May 2000, is a division of Corning Incorporated, located in Corning N.Y.

MISSION The Corning Gallery at Steuben was established in keeping with the long-standing commitment of Corning Incorporated to provide the arts with a forum for dialogue. The Gallery's schedule features four exhibits each year in diverse media including glass. One exhibit each year will be curated by The Corning Museum of Glass, located in Corning New York.

The gallery, open free to the public, seeks to contribute to the diverse cultural landscape of New York. By supporting the visual arts and celebrating extraordinary imaginations, Corning Incorporated seeks to actively enhance our quality of life.

HOURS Monday – Friday 10 a.m. – 7 p.m.
Saturday – 10 a.m. – 6 p.m.

MANAGEMENT The gallery is managed by Patricia Y. Marti, and she can be reached at:
(646) 497- 3744 (telephone)
(646) 497- 3755 (fax)
martipy@corning.com (E-mail)

INFORMATION The public may call (646) 497- 3744 for further information.

#

SAMPLE OF THE FACT SHEET

MEDIA ALERT: COVERAGE INVITED
Contact: Stephanie Frey 201 692-9476

NEW YORK ARTISTS EQUITY ASSOCIATION, INC.

498 Broome Street
New York, NY 10013
Telephone (212) 941-0130

WHAT: **The Changing Face of Art Colonies**

WHERE: Broome Street Gallery
498 Broome Street
New York, New York 10013

WHEN: Thursday, March 3, 7:00 PM
$1 Members $3 Non-Members

WHY: For many artists, art colonies provide an essential boost to their growth and production. In recent years applications to these retreats have doubled and tripled making acceptance difficult and competitive. The problem is further exasperated as private funding sources dictate the criteria for choosing colonists.

This seminar will take a look at some of the country's most popular colonies, explore their attributes, and suggest methods for increasing your chances of acceptance.

WHO: **Donna Marxer:** Moderator
Five-time colonist, author of "The Changing Face of Art Colonies" and "Ragdale, Illinois' Best Kept Secret."

Mary Carswell
Executive Director, The McDowell Colony, Inc., Peterborough, NH

William Edward Smart, Jr.
Executive Director, Virginia Center for the Creative Arts (VCCA), Sweet Briar, VA

Jean Zaleski
Landscape painter and frequent visitor of colonies in the US and abroad.

MAKING THE MOST
OF THE PUBLICITY YOU RECEIVE

Have you received free P.R.? Congratulations! You now have another valuable promotional tool, especially if it is a positive review and the individual is a noted art critic. You can use their endorsements and respected credentials to promote yourself and your work. When you are asked to talk about yourself to a member of the press it may be uncomfortable to speak without sounding boastful. It is much easier to quote someone else who has written a positive review or has commented about your work verbally. Testimonials are certainly helpful: At the very least they confirm the beliefs already held by the reader that your work has merit.

As soon as the article is published make copies of it and add it to your gallery presentation book and your press kit. Also, thank the writer. As a writer I have received many kinds of letters, but among those I cherish the most are the "thank you" notes in response to my published articles. Especially those that are written on cards that artists have made themselves with their art work on them. I frequently frame them display them near my desk.

If the publicity you have received is favorable and comprises a few paragraphs or more, create a press clip by cutting and pasting the article on a page below the publication's masthead. *(See sample in this section.)* Attach them to future press releases and include them in your gallery presentation packages.

QUICK TIPS

- Enlarge the reviews and articles you receive and feature them prominently at your exhibitions.
- Send copies to current and prospective buyers and galleries.
- When you have accumulated a substantial number of positive reviews prepare a Comment Page. *(Refer to the samples in this section.)* You may also quote instructors, art historians, art dealers, curators, collectors and other artists who have made complimentary remarks about your work. In these instances, ask permission to reprint their comments.
- Pull out the positive quotes and add them to your biography, invitations, brochures, catalogues, newsletters and press releases.
- Ask the writer if her or she would be willing to submit the article or another article on your behalf to another publisher.

Manhattan Arts
INTERNATIONAL

September – October 2004

Dellamarie Parrilli

Shares The Healing Power of Art

By Michael Jason

Dellamarie Parrilli is a versatile artist with an extensive and celebrated background in several creative mediums. Heralded by the *Las Vegas Press* as a "triple threat" because of her talent as a singer, dancer and actress, she is now creating paintings that are inspirational, illuminating and transcendent of the ordinary. In a recent essay about her work, Ed McCormack, Editor-in-Chief of *Gallery & Studio* and a former writer for the *Village Voice* and *Rolling Stone*, stated that "few painters at work today come close to her ability to infuse color with a luminosity that suggests a sense of healing energy…"

Searching for the Divine, oil on canvas, 48" x 72"

Dedicated to the creation of art and the healing effect of her creative process, in 1999 Dellamarie turned to painting exclusively. Her ethereal canvases incorporate her belief that "there is little difference between an empty stage, a blank canvas or a sheet of paper or an empty room waiting to be designed. It's about communicating your spirit to others."

Viewers of her work are immediately immersed in the healing qualities of her art. One of Dellamarie's paintings "Above the Clouds" literally lies above the treatment table suspended from the ceiling in Dr. Sally Marshall's office in Woodstock, IL. Dr. Marshall states: "Parrilli's appealing blend of colors and broad flowing brushstrokes set a tone for the patients of safeness and serenity. The patients are very open to express what they feel and for that brief moment in time, feel the vibration of thought and feeling convalesce into peacefulness and relaxation."

Her work is in many other private and public collectors including Lucinda Williams, recording artist; Lt. Governor Kathleen Kennedy Townsend; Busse Wellness Center Ltd; and Dragon's Life System, Inc.

SAMPLE OF THE PRESS CLIP

Several shorter reviews and press clips can be pasted on one sheet, as shown here.

THE DAILY ART PAPER
December 10, 2004

Tjdfijsdfljsgjlgjjl sdlfjslgj lrtjwrli jrtlrjt sdifkjwlgj kjg lgjreltj iotujsovjbhrihtw tjt awoith oith fijwrithj withog uaoa6tu aowirfjreighworgh awirtj oitj wiratj oitj ao;wseilj writj hiorwtuhwtiuq30tuogij awirtjwoaritug writjworitj wiejtoehweo awitjaija awirthtuyhjoqapfvlj awtjihg aweofj ihawrohj aowirjt iajrt aolwrjg aw Awrtigj aitj aioetj iaroithareo art a
Jaolrwtj aritj aitj aitjaoujoaitjaeoitjh p45pwti

Lrtjwrli jrtlrjt sdifkjwlgj kjg lgjreltj iotujsovjbhrihtw tjt awoith oith fijwrithj withog uaoa6tu aowirfjreighworgh awirtj oitj wiratj oitj ao;wseilj writj ohiorwtuhwtiuq30tuogij awirtjwoaritug writjworitj wiejtoehweo awitjaija awirthtuyhjoqapfvlj awtjihg aweofj ihawrohj aowirjt iajrt aolwrjg awAwrtigj aitj aioetj iaroithareo art anof.

Blal Ghiemanadam

Life & Glamour Magazine
Fall 2005

Sally Smith Achieves Luminosity
By Thomas Palette

Tdfjkfjfkj kdkfjsdfjsdfj dfjsdlkfjksflj kdsksdjfskdj. Tdskfjdskfj Thekgjbnkkr ejfj werjejwrkj djfkdjfk sdjfsdjfk jdsfjsdklfj. Idfj tjekgj. Tjejrgjgrjgrj thele; tkejrgjghpwl. Jeirghjgijjfkf tjwerjew kfjfjsdkfjk jfskfjsfkljskflj dfjsdlkfjfkl dlfkjsdklfjsdf. Qjslkfjskj dfkjdflksj fjkdkj lkjflksjfkl kjklje ekrjekrj watjgjekg. Gsdkfjfj sdfj fjsdkfjkflj dfkjsdfk dsfjsdfj. Bdsfjdfj sdfjdlkfj the th.

Kdsksdk tjwjfkjkjf jdfsdjfksjklsj jdfsdjfklsdjfkl. Idfjsdflkjsfj fj dfjdfj tjtjwk tjwltjkw sdsdpfosiuatij ewllkfajwfjgoijoaw;fjekrj ekjraklejr fiujigoujret wtijwtihiujwerjb.

www.ManhattanArts.com

Artist Profile of the Month
Sally Smith

Dskjfdkfjsdkfjkfjsdkfjsdfkjsdkfjsdkfljsdfkjsdkfjds kfjdfjkdfjkfjkfjdsjf dfjkdfjkdfjj dsfjsdfjsdfjfd dkfjdkfj fjdjfkdjfkdjf dfjdkfjdfj djfkdjfkdfj dfjkdfjdkfjd sdkfjkdjfj dfjdfjdj djfd fjdkfdfkdj

Dfkjdfksdkfjdsfjsdkfjsdkfjsdkfj fjkdsjdfj fjkddkj dkkdjfj fdjkdkdj kdfk kfjdfkjfkdsjf djfkdjfkdjf

Dellamarie Parrilli

"Coupled with her chromatic sensitivity, Parrilli possesses a natural gestural fluidity that enhances the immediacy of her canvases immeasurably, imbuing her compositions with rhythmic vigor and vitality. Her painterly vocabulary is so varied as to seem virtually unlimited. In some works, for example, she apparently employs broad strokes of a palette knife in a sgraffito technique, scraping away areas of color, revealing radiant polychromatic layers beneath. In others, densely saturated grounds, stained with diluted oil pigments in the manner of Color Field painting, are combined with tactile impastos applied in sweeping strokes that generate an exhilarating sense of movement and flux."

Ed McCormack, Editor-in-Chief of *Gallery & Studio*
Former writer for *Village Voice* and *Rolling Stone*

"Her work flows and pulsates with a resonance from the world around her. She is at one with nature with its changes of light and rhythm. There is also an aura of spirituality that is pervasive which exudes an uplifting feeling of transcendence and fearlessness… She visualizes universal feelings and emotions with an inner sense of depth and passion for her subjects… Her prior extensive professional background in music and dance is reflected in her work with their lyrical brush strokes and exuberant movements. She literally sings and dances on her canvases."

Nancy di Benedetto, art historian and lecturer, Metropolitan Museum,
and Professor at Marymount Manhattan College

"In everything Dellamarie Parrilli does the beauty of composition seems to be her top concern. Parrilli, who brought art to her music, is now bringing music to her art, and the songs are as lovely as ever."

Edward Rubin, NY Art Writer, *New Art Examiner*
Member of International Association of Art Critics

"Dellamarie Parrilli's paintings are visual journeys to self-discovery. Viewers probe their translucent layers where inner and outer worlds coalesce, contrast and harmonize with each other. The rhythmic compositions and tactile surfaces resonate with passion and inspiration."

Renée Phillips, author, Editor-in-Chief, *Manhattan Arts International*,
and member of International Association of Art Critics

Nancy Shutterspeed

A major visionary photographer and video artist of the twentieth century, Nancy Shutterspeed is also a leading artist advocate. She is an innovative filmmaker and a pioneer in developing beautifully reproduced photography books that evoke the spirit of lands and their people. Shutterspeed is committed to the belief that art, to withstand the test of time, must reveal everyday life and all aspects of current reality. She also believes that artists must experiment continuously, push the envelope with their ideas and their media. She has been an influential force in the local art community of Crophere, IN and has lectured around the United States in many universities and art institutions.

Praise for Nancy Shutterspeed

"Nancy Shutterspeed is one of the unique photographers who has established herself as a singularly historic figure."
 Sue Optic, San Francisco News

"In her own way, Nancy Shutterspeed teaches her audiences how to see."
 Len Viewpoint University

"Nancy Shutterspeed is one of the most interesting image makers on this side of the Mississippi River. She is an artistic trailblazer."
 Samuel Frame, Photography Editor, Finish Gazette

"An advocate and champion for artists' rights Nancy Shutterspeed inspires artists young and old to push boundaries and reach their creative potential. She is a living example of the words she speaks."
 Linda Love, professor, Photo University, NC

"Her work transcends the ordinary reality and takes viewers to extraordinary places. She is a true visionary. Her technique is flawless."
 Dale Dealer, F-Stop Gallery, NY

Robert Halftone

To quote Edward Readme, arts writer and curator:

"While we live in an era that tends to sanctify those who squander their talent and wreak havoc in their personal lives, Robert Halftone is as generous with his ideas as he is inventive with them. He is unabashedly willing to declare his artistic talent and share his success with others." *The Art and Life of Robert Halftone, Five Decades of Painting*

In her book entitled *Modern Painters of New York*, award-winning author Peggy Paragraph commented:

"Robert Halftone has a unique artistic perspective and ardent commitment to his craft. His body of work speaks with candor about the trials and flaws of a society, yet his compassion shines from every tear stained face he paints. He is an artist enormously capable of holding the attention of art enthusiasts world-wide."

Of Robert Halftone's contribution to the art community, Mayor Blossoms awarded him a special citation and stated:

"Our city is indebted to Robert Halftone's artistic contributions. He is a treasured asset in the realm of bringing community awareness to a higher level. He has been a major contributor to the restoration of cultural vitality to our city."

Jack Armstong, President of Laser Corporation remarked:

"It is with enormous pleasure that I announce our installation of Robert Halftone's painting 'Genesis'. Our lobby, visited daily by hundreds of members of the international business community, will now be a sign of welcome."

IMPROVING YOUR VERBAL PRESENTATION

That which we are capable of feeling, we are capable of saying.
Miguel de Cervantes

You will often be asked to discuss your art at a moment's notice – on the telephone or face-to-face with an art dealer, potential buyer or member of the press. And, more than once you will be required to address a group audience at a press conference, opening reception or lecture.

The way you communicate, both verbally and non-verbally, will impact the level of your effectiveness in your career. The art of developing speaking skills to individuals and groups of people can be mastered and the benefits are many. Artists who are proficient speakers increase publicity and advance their careers. Being a confident speaker also empowers other areas of your life.

QUICK TIPS

- Develop a brief introduction that tells people what you want them to know about you and your work. This introduction is sometimes called "the elevator speech" because you should be able to finish it before the listener reaches his or her destination in an elevator ride. The introduction is approximately 30-60 seconds. It is focused and emphatic.
- Know how and when to stop talking. Leave time for a response. If you keep talking, your listener won't be able to ask the questions you would like to hear, such as a request for your brochure, for a studio appointment or for additional explanation. Encourage interaction by coming to a pause, and then wait for your listener to speak.
- Whatever the length of your discussion know your audience and respond accordingly. Develop more than one presentation and make it relevant to your listener. An example of different types of audiences would be general, professional artists and collectors.
- Speak with honesty, pride, confidence and enthusiasm. Deliver your talk without hesitation, excuses, embarrassment or apologies. Sound and look happy about what you do.
- Learn the art of listening. Show interest in what they are saying or asking.
- Make eye contact with your listener as well as everyone in a group audience.
- Before you present a lecture, practice showing images in a slide presentation while simultaneously discussing your work, your process and techniques. You may want to show several slides of the same work to show how your creative process progresses. Hand out promotion materials that they can refer during the lecture and as well as take with them.
- You should also pay attention to your physical appearance – grooming, dress and posture.

PROMOTING YOURSELF WITH A WEBSITE

HAVING YOUR OWN ONLINE PORTFOLIO

*The new electronic independence
recreates the world in the images of a global village.*
Marshall McLuhan

Today, a website is essential for anyone who wants to attract business. For an artist who is interested in gaining exposure, recognition, promotion and sales a website is a necessary tool. With an abundance of easy to use website software available this task is no longer a difficult, expensive challenge. Additionally, Internet service providers offer free space and easy to follow instructions. If you don't know how to set up your own site, chances are you probably know a talented technologically adept child like my nieces Cheri and Vanessa (12 and 8 respectively) who can probably help you with it.

The benefits of having your own website begins by providing you with an unlimited international audience with 24-hour viewing. A website makes your art immediately accessible to a wide range of collectors and art world professionals. It is a convenient tool for introducing your work to galleries. At most, you can add all the latest shopping cart accessories and become your own high tech mega gallery and sell your work directly to buyers. Having your own website will make it possible for you to link with other sites and online galleries.

ADVICE FROM STEPHEN BEVERIDGE

Computers are useless.

They can only give you answers.

Pablo Picasso

Stephen Beveridge is a New York-based artist who also designs and maintains websites for artists and art-related businesses. *(See Resource section of the book for contact information.)* Stephen offers this sage advice:

Put yourself into your user's shoes before planning your site's content. Ask yourself some basic questions. Why would they come to your site? What can you do to make sure their visit is rewarded? What do you want your website to be – a casual showcase for your work or an ambitious tool for promotion and sales?

GETTING STARTED: PLANNING YOUR WEBSITE

A good website requires forethought. Begin with a mission statement and stick to it. Spend time looking at some art websites. Start making drawings of what you might like your home page to look like. It will save a lot of time and energy if you plan the entire site on paper. Make a list of the areas on your site. For example, your site will contain: home page; biography; artist's statement; a list of exhibitions; paintings; sculpture; thumbnails; and slideshow. Include a photograph of yourself. List your name, address and phone number, an e-mail link and other web sties on which you appear. Each page should have some elements that remain the same – navigation, title and contact information. Draw what you want on each page on 4" x 5" index cards. This way you can lay them on the table showing their relationships to each other. Think of it as a big tree with branches crossing and all coming from the title page root. Be specific in your drawing and show relationships on the page between text, images and negative space.

When planning your images always work from slides or digital photos as the tonal range is much greater than a paper photograph can provide. I advise having your slides scanned onto a Kodak Photo CD (not picture CD). Photo CD images are produced using Kodak scanning algorithms and color management software, ensuring consistent, high-quality color. Each Photo CD Master disc provides long-term, low-cost storage of approximately 100 images. You can have a 24-exposure roll of 35mm film scanned onto a

Kodak Photo CD Master disc for under $25. Slides are usually around $2.25 to scan and the disc costs $8. For that price you get a better scan than is possible at home.

You must remove the images from the Photo CD and create 72dpi jpeg images for the site. The size and compression of these images is crucial to the loading time of the web page. If I have to wait too long for a large image to load you will lose your audience. This is one reason to use a designer who has worked with visual artists. They will have the image editing software and the knowledge of how to make your images load quickly and look their best.

Write an "elevator speech" (a brief, concise description of your work) for your home page. Write your biography and exhibition statement and store it on your computer so it will be ready to put on your site and will be easy to update when needed.

There are two basic aspects to a website: the actual site pages; and the domain name. The pages, images, music, and any other digital data reside on a server at the web hosting company. They are denoted by numbers that you will probably never see.

CHOOSING YOUR DOMAIN NAME

Select a domain name, also referred to as a URL. Make sure it is something easy to remember, type and spell. This is the name that goes between the www and the dot com. Think of it as your nickname on the web. It would be nice to use your name but keep in mind you want it to be as easy as possible for someone to find your site. If you can say, "go to joeart.com" they will probably not forget or misspell it, but if you say "go to JoePetrovichArtAbstractOnline.com" they may misspell, get one or more of the caps wrong, or lose interest because there's too much typing involved. Go to www.idomains.com or www.register.com and enter your chosen URL to see it if is already taken. There is a separate charge for a domain name and it is best purchased at the time you get the server because they hook it up or point it to the server with a minimum of fuss. I suggest you sign up for at least three years in advance.

FINDING YOUR WEB HOST

You need a web hosting company. Web hosting companies rent space to you on their server. The have buildings filled with these servers and backup servers located elsewhere in the event of power failure. Your web site is available to anyone, any time. They charge a set up fee and a monthly fee and allow you to run e-mail through the website using your domain name (i.e., joe@joeart.com). Some website hosting providers include: IPOWERWEB; StartLogic; Jumpline; Infinology; iPage; LunarPages; PowWeb; Globat; Easy CGI Web; and HostRocket.

INTERNET SERVICE PROVIDER (ISP)

An Internet Service Provider is the company (i.e. Earthlink, or AOL) that provides access to the world wide web. This is the place your computer calls when your modem squeals and beeps. Your ISP probably offers to host your web pages. Find out how much it costs, and if they allow you to use your own domain name. You can probably get it free if you are willing to keep it small and use your ISP's domain name in the URL (your internet address.) For example your address could be, www.member.aol.com/yourname. If you want your own domain name as in www.yourname.com they charge a monthly fee. In that case they become your web host. A disadvantage to using an ISP to host is that web hosting is not their area of expertise.

SEARCH ENGINES

Once your website is up and you are satisfied with it you will want to announce it to the world. One way is through listing it with the search engines. A search engine is a database of web pages. You give them your URL, and they read your page, extract relevant information from it, and store it in their database. Many search engines also run "spiders" that roam around the net looking for new pages.

Depending on your purposes this could be vital. The search engine is the place where you go to find something on the web. You type in a key word or phrase and the engine searches it's database for sites using those words. If you want to achieve high ranking by the search engines it is important to make your site attractive. This involves choosing the right key words and adjusting your page title, Meta tags and first paragraph to showcase them.

Search engines look for words on the actual page as well as in the code (Meta tags). Write something about your work using the keywords. Each image has the ability to hold Alt tags which are generally words describing that image to browsers without image capability or with that capability turned off. You can often see these tags as the image page loads. Put a couple of keywords here as well as the title of your work.

One of the best strategies is to view the source codes of the "Top 10" or "Top 25" sites that appear under keywords that fit your site. Study their titles, Meta tags, comment tags, keyword density, and Alt image tags and look for common things among the top ranking pages. In AOL for MAC I hold down the mouse button in the background of a page and I get a window with an option to view source. In Internet Explorer and Netscape Navigator the view menu at the top of the screen has a source option. The Meta tags are near the top of the page of source code.

Think about what search terms you would use if you were looking for your specific artwork. Are you a three-legged gymnast with surreal crayon drawings? List the search terms that apply to you and see who else is doing similar work and what search terms they have used.

Each engine has a place, usually at the bottom of the search page, to submit your URL. Use this feature on at least your favorite engines and fill in the information requested. Be prepared with your own keywords and a description of your site using those keywords.

Search engines work in different ways and you could spend all your time trying to tailor your pages to match their search habits and submitting repeatedly just to keep on top. It seems that every day new engines are created which work in new ways. Information about all aspects of registering and designing for optimum recognition can be found at http://searchenginewatch.com/

Even though it's possible to list in the search engines for free you can spend a lot of time, money and energy on getting information to them and it may take months to take effect. Experts agree that an excellent way to get noticed is to trade links with other web pages. Not only will visitors of like-minded sites learn about yours, but once you link with popular pages the search engine spiders can find you and begin to list you.

MAJOR SEARCH ENGINES

Google: www.google.com
AllTheWeb.com (FAST Search): www.alltheweb.com
AltaVista: www.altavista.com
AOL Search: http://search.aol.com/
Ask Jeeves: www.askjeeves.com
HotBot: www.hotbot.com
Inktomi: www.inktomi.com
LookSmart: www.looksmart.com
Lycos: www.lycos.com
MSN Search: www.search.msn.com
Open Directory: http://dmoz.org/
Netscape Search: http://search.netscape.com
Yahoo: www.yahoo.com

In a few minutes a computer can make a mistake so great
that it would take many men many months to equal it.
Merle L. Meacham

QUICK TIPS

- Make sure all your images display properly and quickly.
- Make sure your links are operating.
- Check spelling and grammar.
- Be clear and concise.
- Avoid slang and colloquialism, since your website will be viewed by an international audience.
- Avoid using unnecessary large images that will slow down your visitors' loading time.
- Avoid using unnecessary colored and patterned backgrounds that will compete with your images and make reading text difficult.
- Colors and text flow vary from browser to browser, so try to prepare a universal look and view your website on different browsers.
- Think twice before accepting banner ads, or using Java Script, Flash, scrolling messages, animated gifs, and music. Ask yourself, will these devices detract from or enhance my art work and the visitor's experience?
- Keep your website updated. Visitors will not return if the information is stale.
- A friendly picture of you working in your studio looks good on the home page.
- Print your website address on all your correspondence, business cards and advertising.
- Look for other websites with whom to exchange links.
- Submit your site to the search engines every month.
- Beware of companies offering to list you in 3,000 search engines for a fee.
- Promote your site.
- Check out the many articles, books and courses on and off line that will help you design your site, promote it and handle the traffic you get.
- Offer reciprocal links with compatible sites to drive more traffic to yours.
- Sit back, relax and enjoy your worldwide exposure.

CHAPTER 6

GETTING IT
SIGNED, SEALED & DELIVERED

Poor artist! You gave away part of your soul when you painted the picture
which you are now trying to dispose of.
Paul Gauguin

BUILDING THE ARTIST / DEALER RELATIONSHIP

Before you walk hand-in-hand into the sunset with your new dealer or agent please read this section carefully and apply the instructions. If you expect to have a more than casual relationship with one or the other a written contract is essential. A contract is a tool that informs both parties of their responsibilities and objectives. It is necessary in order to establish clarity, understanding and legal protection. Chances are, you will have a good working relationship with your dealer, and once the agreement is written you may never have to refer to it, but it will be comforting to know it exists.

You may encounter dealers who do not use contracts and may argue that one is not needed. There will be those who have them and they were designed to protect *their* interests, not yours. In either case, it is your responsibility to procure a signed agreement that protects *your* interests.

If you don't understand every detail of a contract that is offered to you, ask questions until you do. Take the time to safeguard your rights and your artwork in the beginning of a relationship rather than risk

losing your art to business failure, neglect, forgetfulness or unscrupulous behavior. Don't leave any art work without a signed consignment agreement.

If a letter is to serve as a contract, plan carefully before you write it. List all items that will protect your agreements, including time limits, payment dates and price ceilings. The complexity of your artist / dealer relationship will determine how detailed the contract is.

Your contract does not have to read like a legal document. You may write it in a manner as though you are speaking. Use personal pronouns such as "I understand I will receive… in exchange for …" At the same time it must reflect a business-like tone. Have someone familiar with art law examine it thoroughly. Whenever you mail a contract make sure you register it with the post office with a return-receipt to keep for your records.

There are many resource books available that contain guidelines and sample contracts, such as *Business and Legal Forms for Fine Artists* by Tad Crawford. *(Refer to the Resource section of this book.)* You should also be aware of Volunteer Lawyers For The Arts, an organization that provides arts-related assistance to artists, with chapters in New York and other cities. The advice for having contracts with dealers should also be applied with dealing with artist's agents, consultants and curators.

THE ARTIST/DEALER AGREEMENT CHECKLIST

Several key questions are provided below which you should attempt to obtain the answers to when negotiating with a dealer prior to your written agreement. Of course, every point may not be necessary in every situation, but being aware of these points will be helpful. You will want to customize a written agreement that suits your individual needs and scope of the relationship.

- Who are the parties involved? Who is the owner(s) of the gallery or president of the company?
- What is the duration of the contract? Is it for a fixed term? Contingent on sales? What options do either of you have to extend the term of duration?
- Does your written agreement provide for termination in the event of the owner's or director's death, or if the change of ownership should occur or if the dealer should move?
- Does it provide for termination in the event of the gallery's bankruptcy or insolvency?
- How much art does the dealer want?
- How long will the dealer keep the work?
- If you want your artwork returned, how much notice is required?
- Where will the work be shown? Will it be visible to visitors or hang in a back room? Will the artwork ever leave the gallery premises for exhibition purposes? Will you be notified prior to it leaving the premises?
- Will the dealer prepare a press release for your exhibition?

- Will you be able to approve, edit or revise the press release?
- If your work is in storage at any time, do you have access to it?
- What will happen if the exhibition is cancelled due to natural disasters?
- How many other artists' works are being exhibited at the same time? When will your work be exhibited? What is the length of the exhibition?
- Who has the control over the installation?
- Is the representation exclusive by geography and/or media? Can you sell your work in other galleries or through other dealers throughout the U.S. and abroad?
- Can you approach museums for exhibitions and sales without the dealer's permission?
- Does your representation include sales of artwork in your studio? Does the dealer expect a commission on sales of your work when sold outside their gallery?
- Does the dealer have permission to sell your work at auctions?
- Does your representation include work of yours in other media?
- What kind of promotion will the dealer provide for you?
- What is the extent of the advertising? Who makes the decisions about advertising?
- Who makes the decisions about catalogues, opening receptions and mailings?
- Who determines the retail price of your work?
- When will you be notified of sales?
- How soon will you get paid after the sale?
- Will the dealer release the names and addresses of the buyers of your work?
- What is the dealer's commission?
- Will the commission rate decrease as the volume of sales increases?
- Does the commission vary from one medium to another?
- Does the dealer have permission to negotiate commissioned works on your behalf?
- Does the dealer have permission to rent or lease your work?
- What are the dealer's policies for trading up work and returns?
- What are the terms for the dealer purchasing your work for their ownership?
- If you provide your own mailing list to help in the promotion of the exhibition, will the list be kept confidential and not used for other promotional purposes?
- Does the dealer give discounts to buyers? How much? Will the discount be deducted from your share of the profit?
- What insurance coverage does the dealer have for your work? What are the terms of the insurance policy? Does it cover the full retail value of your work? Is your art work protected in-transit, on-site?
- Has the dealer declared responsibility for loss or damage of your artwork from the time it is received until it is returned you?
- If there is damage to your work, who chooses the restorer? How will you be compensated?
- If the dealer promises your work will be featured on his/her website and if they have technical difficulty, will they compensate you in some way if your work does not appear?
- Will the dealer allow you to have your own website and promote it? What about arranging reciprocal links to and from each other's website?
- What expenses does the dealer expect you to incur? Make sure they are enumerated in the written agreement.

- Who will pay for the shipping expenses for the work to go to and from the dealer, carriers, craters and buyers?
- Who will pay for the framing, photographs, slides and transparencies?
- Do they have a budget for the exhibition and discuss with you how the money will be spent?
- Who will own the frames, pedestals, negatives, transparencies and other property?
- Regarding the accounting: Has the dealer agreed to periodic accountings during which the dealer will share information regarding the payment and location of the art?
- Who has to give permission for your work to be used for book, magazine and website reproduction? For group exhibitions inside and outside the gallery?
- Who has reproduction rights prior to the sale of your work, retention on transfer or sale of work? What about copyrights?
- What are the state's laws regarding arbitration of the contract?
- Does the dealer have the right to any portion of income you receive from lectures, prizes/awards and reproduction rights?

ABOUT THE CONSIGNMENT AGREEMENT

Some dealers buy artwork from artists outright. Most dealers work on a consignment basis, which means you leave your artwork in their custody and they pay you when they sell the work. In other words, upon the delivery of a consigned work, the dealer is the agent of the artist, the work delivered is trust property and the sale proceeds are trust funds held for the benefit of the artist-consignor. The Consignment Agreement is used when you leave your work in someone else's custody, such as a gallery owner.

The Consignment Agreement is a vital tool to protect the artist by showing the artist's ownership of the work. A simple Consignment Agreement should specify the dealer's receipt on consignment of certain works. The title, medium, size, date of creation, nature of signature, retail price and the dealer's commission percentage on each work must be listed. The agreement must also state when payment must be made to the artist. It must specifically state that the artist is the owner of the work until title passes to the purchaser. This is important because, should the dealer go bankrupt, it shows they are not the owners and their creditors cannot claim your art work. The agreement must also state that it is limited to the work listed, and the dealer cannot claim commissions on works other than those consigned. The Consignment Agreement should be attached to, but is not designed to replace, the Artist / Dealer Agreement.

Remember, when signing an agreement do not agree to a "net price" commission, under which the dealer agrees to pay a fixed amount to you when the work is sold, since this will allow the dealer to charge higher prices and, in effect, pay a lower commission rate.

SAMPLE OF THE ARTIST / DEALER AGREEMENT

Agreement between _____ (artist) residing at _____

and _____ (dealer) located at _____

on date: _____ .

The artist is interested in having artwork represented by the dealer and the dealer is interested in representing the artist under the following terms:

1. Scope of representation: The dealer will represent the artist exclusively within the following geographical area: _____ . Exceptions are: _____ . Artist's income from other sources such as awards or lecture fees shall not fall under the scope of dealer representation. Studio sales shall/shall not (strike one) fall under the scope of dealer representation. Commissions resulting from the dealer's referral shall not exceed _____ % of the retail price.

2. Consignment/Price/Commissions: The artist's work shall be held on consignment with the dealer and offered for sale at the retail price listed on attached consignment record. The dealer will receive _____ % of the retail price upon sale and the artist will receive _____ %. No discounts shall be given by the dealer with the exception of: _____ . All discounts will be deducted from the dealer's percentage of retail. The work is and will remain the sole property of the artist until sold.

3. Reproduction: Except as stated below and to extent the permitted by law, the artist shall retain all rights to reproduction of work. Sale of the material object does not constitute transfer of the artist's copyrights.

4. Duration: This contract shall be in effect through (date) _____ , and may be cancelled only with sixty days written notice by either artist or dealer. Said notice shall be mailed by certified or registered mail to the last known address of artist or dealer.

5. Exhibitions: The dealer will arrange a one-person show for the artist each year for _____ years from the date of the signing of this Contract. The show will be scheduled between September and May and shall last for _____ days.

6. Expenses: Expenses resulting from exhibition of work shall be divided in the following percentages:

	Artist	Dealer
Shipping of work to dealer (including insurance and packing)	_____	_____
Advertising ...…………	_____	_____
Catalogues ..……………	_____	_____
Announcements ..…………	_____	_____
Framing ..….........……	_____	_____
Photography ...……........	_____	_____
Opening reception ...…………	_____	_____
Shipping to purchaser ...…………	_____	_____
Return shipping ..…………..	_____	_____
Miscellaneous expenses ...……………	_____	_____

7. Payment: Except as stated below, the artist shall be paid for all work sold within 30 days of sale.

Monthly records will be maintained by dealer for artist. No arrangements for installment payments will be made without the artist's approval, and in such instances, the artist's percentage of retail will be paid before the dealer's percentage.

8. Assignment: This agreement is not assignable by either party.

9. Insurance: All of the artist's work consigned to the dealer will be insured by the dealer for _____% of the retail price for the artist. Any loss or damage that occurs while the work is in the dealer's possession which is not covered by insurance will be covered by the dealer provided that the dealer's liability under this paragraph is limited to the amount which would have been due the artist if the work had been sold at the price stated herein.

10. This Contract has been modeled according to the provisions of the Illinois Act in relation to the consignment of works of fine art, as now or hereafter amended, and constitutes the entire agreement between the parties. Any changes in the foregoing contract must be in writing, dated and signed by both the artist and the dealer.

_____ (Artist) _____(Dealer)

_____ (Signature) _____(Signature)

Editor's Note: This contract is reprinted with permission from the Chicago Artists' Coalition. The Chicago Artists' Coalition and the publisher of this book strongly advise each artist to tailor contracts to meet individual needs. This sample contract is provided only as a consideration of terms that might be included. You should check your national artist's organizations for a contract that abides by your state's laws.

SAMPLE OF THE CONSIGNMENT AGREEMENT

Date: _____

Artist / Consignor

Name:_____

Address:_____

Gallery / Consignee

Name:_____

Address:_____

This is to acknowledge receipt of the following works of art on consignment:

TITLE	SIZE	MEDIUM	DATE OF CREATION	NATURE OF SIGNATURE	RETAIL PRICE	COMMISSION

Term of consignment Date From:_____Through_____

Responsibility: The gallery will assume full responsibility for any consigned work lost, stolen, or damaged while in its possession. Consigned works may not be removed from the Gallery's premises without written permission from the Artist.

Sales: The specified retail prices may not be changed without the Artist's permission. In the case of discount sales, the discount shall be deducted from the Gallery's commission.

Commission: The Gallery shall receive a commission of ____ percent of the retail price of each work sold.

Payment: The Artist will be paid within two (2) weeks of the sale.

Title: The title to these works remains with the Artist until these works are sold and the Artist is paid in full, at which time the title passes directly to the purchaser.

This consignment applies only to works consigned under this agreement.

The consigned works will be held in trust for the Artist's benefit and will not be subject to claim by a creditor of the Gallery.

This agreement will terminate automatically upon the Artist's death, or if the Gallery becomes bankrupt or insolvent.

The Artist or the Gallery may end this agreement with thirty (30) days notice.

Consented and Agreed to:

Gallery _____ Date: _____
 Company Name

Authorized by _____
 Authorized Signature

THE ARTIST / BUYER RELATIONSHIP

Selling your work is a time for celebration. It is also a time when you shouldn't forget to safeguard your artwork after it leaves your possession. After the payment is made and the check clears you are still entitled to certain rights as the creator. Whether the sale is of work that is already in existence or is a commissioned piece, you should obtain a written contract, also known as a Bill of Sale, from the purchaser.

This simple form of a Bill of Sale should include: the purchaser's name; address; telephone number; the date; description of the work; the purchasing price; the sales tax if applicable; and whether the purchase was made, or will be paid, in cash or with a credit card. Obviously, this information is valuable for a number of business and tax purposes.

The Bill of Sale should be expanded to include other important measures of protection.

ENTER THESE CLAUSES UNDER TERMS OF SALE

- The Purchaser must inform the Artist if the artwork is sold, transferred or donated. California state law requires that 10% of the amount over the original price shall be given to the artist by the seller.
- The Purchaser must inform the Artist of the new owner and the price of sale.
- If the artwork is rented out by the Purchaser, the Artist shall receive ___ % of rental income.
- Artist shall have the right to photograph the artwork, if necessary, for publicity or reproduction purposes.
- Artist shall have the right to include artwork in retrospective show for a maximum of ___ months.
- Artwork cannot be exhibited in public without written approval from the Artist.
- The Artist reserves all rights whatsoever to copy or reproduce the work to the Artist, his or her heir, executors, administrators and assigns. The Artist has placed a copyright notice of his or her name on the Work.
- The Artwork shall not be reproduced without the written permission of the artist and copyright notice must accompany the reproduction.

SAMPLE OF THE BILL OF SALE FORM

YOUR NAME, ADDRESS, TELEPHONE, E-MAIL, WEBSITE

Purchaser's Name: _____

Purchaser's Address: _____

Purchaser's Phone: _____

DESCRIPTION OF WORK:

Title: _____ Date completed: _____

Size: _____ Medium: _____

Framing: _____ Other: _____

TERMS OF SALE:
(See previous page for additional clauses to enter here.)

Purchase price: _____

Sales or transfer tax: _____

Shipping: _____

Total: _____

Payment: __ Cash __ Check __ Credit Card

If an installment payment has been arranged you should include this clause:
The price shall be paid in _____ equal monthly installments, commencing on the ___ day of
_____, 20_____.

Received in good condition: _____
 Signature of The Purchaser

SAMPLE INVOICE FOR THE SALE OF AN ARTWORK

This is an important record of transaction to record sales prices, to record purchasers' names and addresses and for tax purposes.

YOUR NAME, ADDRESS, TELEPHONE, E-MAIL, WEBSITE

Purchaser's Name: _____

Purchaser's Address: _____

Purchaser's Telephone/E-mail : _____

DESCRIPTION OF WORK:

Title: _____ Date completed: _____

Size: _____ Medium: _____

Framing: _____ Other: _____

(Additional information can be entered here, such as a description of a limited edition print, or a commissioned artwork.)

Price: _____
Framing: _____
Shipping / Delivery: _____
Sales or Transfer Tax: _____
Total: _____
Deposit: _____
Balance due: _____

Payment is due upon receipt of invoice. (or) Payment is due by (date) _____(or)
Paid in full: (date)_____Thank you.

Your signature: _____

If previous invoices have been ignored, you may add:
This invoice is _____ days overdue. If you cannot make immediate payment please contact me/us immediately. (or) We must collect payment immediately. If payment is not made within the next ten days, we have no choice but to turn this account over for collection. This process may result in additional legal and court costs to you and may damage your credit rating.

SAMPLE CERTIFICATE OF AUTHENTICITY FOR A PRINT

This document provides reassurance about the limited edition print the purchaser owns. You can also offer tips on caring for the print. See next page.

YOUR NAME, ADDRESS, TELEPHONE, FAX, E-MAIL, WEBSITE

Photograph of the Print

This certificate hereby verifies the authenticity of the accompanying fine art print.

My signature, on each print and this document, attests that I have personally inspected, numbered, signed and approved that each print is an authentic reproduction of my original work of art.

I also certify that only the finest archival papers and high quality inks were used in the workmanship of my reproduction.

After the printing run of this edition, the printing plates, production film and proofing sheets, with the exception of _____ signed artist's proofs, which will remain unnumbered, were destroyed.

I hereby guarantee that no additional reproductions will ever be made.

Title: _____

Medium: _____ Edition size: _____

Individual Number:_____Year of original work: _____

Date edition signed: _____ Date of sale: _____

Artist's name: _____

Artist's signature: _____

SAMPLE RECORD OF SALES

BUYER	DESCRIPTION	PRICE	OCCASION	NOTES
Ellen Green 200 East 20 St. Bigtown, NY 10000 555-123-4567 E: ellen@green.com	Bluegrass, 2001 Oil on canvas 24" x 48"	$800	Open studio 10/20/02	Paid 10/02/04 Interested in purchasing "Forest". Will return with her husband. **Follow up**
Crown College Sue Spence, Director Purchasing Dept. 123 4th St. Kingston, VT 10000 555-123-3456 E: sue@crown.org	Sunset over Manhattan o/c, 2002 36" x 48"	$1,200	Referred by Graig Gallery, VT	Delivered painting 12/5/04
Mr. & Mrs. Frank 111 Second Ave. Townsville, VA 00000 555-123-9876 E: bfrank@aol.com	Honeycomb O/C, 2002 36" x 60"	$1,500	Gold Gallery solo show December	1st installment 3/6/04 2nd installment due 4/6 Final payment due 5/6

AFTER THE SALE CARE INSTRUCTIONS

After the sale, you will want to make sure your artwork is properly cared for. Since most people are not aware of what is required, you may want to provide some tips to the buyer on the proper hanging and care of your work. Once the piece is out of your possession, you will want to insure its longevity, not only for the pleasure of the buyer, but for posterity. You may also want to borrow the work for a retrospective exhibition at a later date.

Fragile works of art, including works on paper, require special handling and framing instructions. The new owner will be pleased to have this valuable information and can pass it along when and if they decide to resell it or bequeath to an heir.

The following tips can be typed and attached to the Certificate of Authenticity.

CARE INSTRUCTIONS

- Prints should not be hung in rooms that have strong daylight. Filters, lenses, or glass barriers may filter out rays, but sunlight and florescent illumination must be avoided.
- Art should not be hung directly opposite windows. Special screens may be inserted in windows to decrease damage.
- The artwork should be lit evenly to avoid fading. Direct and indirect sunlight and florescent lighting contain ultraviolet rays that are harmful to paper as well as to certain inks and colors.
- Heat can also be damaging to works on paper. Light fixtures, especially halogen lights, can generate heat. Also, radiators and other heating elements can cause damage.
- Avoid hanging art on damp walls. If the relative humidity is above 70% mildew may appear on the paper. Air conditioners and dehumidifiers protect art against the damages caused by high humidity. If the humidity falls below 30% the paper may become brittle.
- You should examine the condition of the artwork periodically. If there is discoloration where the mat meets the art, acid-free mats should be replaced by a professional framer.

NOTES OR DOODLES

RESOURCES

BOOKS / DIRECTORIES

303 Marketing Tips: Guaranteed to Boost Your Business by Rieva Lesonsky and Leann Anderson. Published by Entrepreneur.

365 Ways to Simplify Your Work Life by Odette Pollar. Published by Dearborn.

Artist's and Graphic Designer's Market edited by Mary Cox. Published by F & W.

Photographer's Market: Places to Sell Your Photographs edited by Megan Lane. Published by F & W.

The A-Z of Art: The World's Greatest & Most Popular Artists & Their Works by Nicola Hodge and Libby Anson. Published by Advanced Marketing Services, Inc.

A Guide to Art: A Handy Reference to Artists, Their Works, and Artistic Movements by Sandro Sproccati. Published by Abrams.

And I Quote compiled by Ashton Appewhite, William R. Evans III and Andrew Frothingham. Published by St. Martin's Press.

Art and Its Histories: A Reader by Steve Edwards. Published by Yale University Press.

Art and Photography by Aaron Scharf. Published by Viking Penguin.

Art and Reality: The New Standard Reference Guide and Business Plan for Actively Developing Your Career as an Artist by Robert J. Abbott. Published by Seven Lock.

The Art Dealers by Laura de Coppet and Alan Jones. Published by Clarkson N. Potter, Inc.

The Art Business Encyclopedia by Leonard DuBoff. Published by Americans for the Arts and Allworth Press.

The ArtFair SourceBook: The Definitive Guide to Fine Art & Contemporary Craft Shows in the United States published by Sourcebook Publishing Co.

Art in America Guide to Museums, Galleries & Artists. Published by Art in America in August.

Art Information and the Internet: How to Find It, How to Use It by Lois Swan Jones. Published by Onyx Press.

Artists and Writers Colonies by Gale Hellund Bower. Published by Blue Heron Press.

Artists' Communities Directory published by The Alliance of Artists' Communities, Portland, Oregon.

Artist to Artist: Inspiration and Advice from Artists Past and Present compiled by Clint Brown. Published by Jackson Creek Press.

The Artist-Gallery Partnership: A Practical Guide To Consigning Art, by Tad Crawford and Susan Mellon. Published by Allworth Press.

TheArtist's Complete Health and Safety Guide by Monona Rossol. Published by Allworth Press.

The Artist's Friendly Legal Guide by Floyd Conner et al. Published by North Light Books.

The Artist's Guide To New Markets: Opportunities To Show And Sell Art Beyond Galleries by Peggy Hadden. Published by Allworth Press.

The Artist's Resource Handbook by Daniel Grant. Published by Allworth Press.

The Artist's Survival Manual: A Complete Guide To Marketing Your Work by Toby Judith Klayman. Published by Charles Scribner's Sons.

The Artist's Way: A Spiritual Path to Higher Creativity by Julia Cameron. Published by Tarcher/Pedigree Books.

Art Law: The Guide For Collectors, Investors, Dealers, and Artists, by Ralph E. Lerner and Judith Bresler. Published by Practicing Law Institute.

Art Law Handbook edited by Roy S. Kaufman. Written by a team of practicing art law authorities. Published by Aspen Law & Business.

Art Marketing Handbook: Marketing Art in the Nineties by Calvin J. Goodman and Florence J. Goodman. Published by Gee Tee Be.

Art Marketing 101: A Handbook For The Fine Artist by Constance Smith. Published by Art Network.

Art Office: Business Forms, Charts, Sample Letters, Legal Documents & Business Plans For Fine Artists by Constance Smith and Sue Viders. Published by ArtNetwork.

Arts Wire Web Manual published by New York Foundation for the Arts. (212) 366-6900. www.nyfa.org

The Business of Art edited by Lee Caplin. Published by Prentice-Hall.

Business and Legal Forms For Fine Artists by Tad Crawford. Published by Allworth Press.

Business and Legal Forms For Photographers by Tad Crawford. Published by Allworth Press.

The Business of Being An Artis, by Daniel Grant. Published by Allworth Press.

Caring For Your Art by Jill Snyder. Published by Watson-Guptill.

The Complete Idiot's Guide to Starting Your Own Business by Ed Paulson and Marcia Layton. Published by Macmillan Publishing Co.

The Copyright Guide: A Friendly Guide to Protecting and Profiting from Copyrights by Lee Wilson. Published by Allworth Press.

The Concise Oxford Dictionary of Art and Artists by Ian Chilvers. Published by Oxford University Press,Inc.

The Crafts Supply SourceBook: A Comprehensive Shop-by-Mail Guide for Thousands of Craft Materials by Margaret Ann Boyd. Published by F&W.

Chronicles of Courage: Very Special Artists by Jean Kennedy Smith and George Plimpton. Foreword by Robert Coles. Published by Random House.

Editor and Publisher's Annual Directory of Syndicate Services Issue published by Editor and Publisher Company.

Everything's Organized by Lisa Kanarek. Published by Career Press, Inc.

Finding Your Perfect Work: The New Career Guide to Making a Living, Creating a Life by Paul Edwards and Sarah Edwards. Published by Putnam Publishing Group.

Fine Art Publicity: The Complete Guide For Galleries And Artists by Susan Abbott and Barbara Webb. Published by the Art Business News Library.

The Fine Artist's Career Guide by Daniel Grant. Published by Allworth Press.

The Fine Artist's Guide To Marketing And Self-Promotion by Julius Vitali. Published by Allworth Press.

The Fine Artist's Guide To Showing And Selling Your Work by Sally Prince Davis. Published by North Light Books.

Foundry Guide & Directory: An A-Z Comparison of 100 Foundries published by International Sculpture Center.

Go Wild! Creative Opportunities for Artists in the Out-of-Doors compiled by Bonnie Fournier. Published by Lucky Dog Multi-Media.

Herstory: Women Who Changed The World by Ruth Ashby and Deborah Gore Ohrn. Introduction by Gloria Steinem. Published by Viking.

How to Get Started Selling Your Art by Carole Katchen. Published by F & W.

How to Handle 1,000 Things at Once: A Fun Guide to Mastering Home & Personal Management by Don Aslett. Published by Marsh Cree.

How To Photograph Paintings by Nat Bukar. Published by Art Directions Books.

How to Photograph Your Art by Malcolm Lubliner. Published by Pomegranate Press.

How to Photograph Your Artwork by Kim Brown. Published by Canyonwinds.

How to Start And Succeed as an Artist by Daniel Grant. Published by Allworth Press.

How To Survive And Prosper As An Artist by Caroll Michels. Published by Henry Holt and Company.

Inside The Art world: Conversations With Barbaralee Diamonstein published by Rizzoli.

Legal Guide For The Visual Artist by Tad Crawford. Published By Allworth Press.

Life, Paint and Passion: Reclaiming The Magic of Spontaneous Expression by Michell Cassou and Stewart Cubley. Published by G. P. Putnam's Sons.

Making Money with Your Creative Paint Finishes by Lynette Harris. Published by F & W.

Marketing Made Easier: Guide To Free Organizing Artists published by National Association of Artists' Organizations.

The McGraw-Hill Guide to Starting Your Own Business: A Step-by-Step Blueprint for the First-Time Entrepreneur by Stephen C. Harper. Published by McGraw-Hill.

Money For Visual Artists published by Americans for the Arts with Allworth Press.

The Complete Guide to NEW YORK ART GALLERIES by Renée Phillips. Published by Manhattan Arts International. *(See order form in this book.)*

New York Publicity Outlets published by Public Relations Plus, Inc.

Organizing Artists published by National Association of Artists' Organizations.

The Overwhelmed Person's Guide to Time Management by Ronnie Eisenberg. Published by NAL/Dutton.

The Oxford Dictionary of Art edited by Ian Chilvers, Harold Osborne, and Dennis Farr. Published by Oxford University Press.

Photographing Your Artwork: A Step-By-Step Guide To Taking High Quality Slides At An Affordable Price by Russell Hart. Published by North Light.

The Positive Principle Today by Norman Vincent Peale. Published by Fawcett Book Group.

Professional's Guide To Publicity by Richard Winer. Published by Public Relations Publishing Co.

The Publicity Manual by Kate Kelly. Published by Visibility Enterprises.

Restoration of Paintings by Knut Nicolaus. Published by Könemann.

The Seven Habits of Highly Effective People by Stephen R. Covey. Published by Simon & Schuster.

The Seven Spiritual Laws of Success: A Practical Guide to the Fulfillment of Your Dreams by Deepak Chopra. Published by Amber-Allen Pubishing and New World Library.

Small Business for Dummies by Eric Tyson and Jim Schell. Published by IDG Books Worldwide.

Success Is a Journey: 7 Steps to Achieving Success in the Business of Life by Jeffrey J. Mayer. Published by McGraw Hill.

Taking The Leap: The Insider's Guide To Exhibiting And Selling Your Art by Cay Lang. Published by Chronicle Books.

The Thames and Hudson Dictionary of Art Terms (World of Art) by Edward Lucie-Smith. Published by Thames & Hudson.

Time Management For Busy People by Roberta Roesch. Published by McGraw-Hill Companies, Inc.

Time Management For The Creative Person by Lee Silber. Published by Three Rivers Press.

Time Management for Dummies by Jeffrey J. Mayer. Published by IDG Books Worldwide.

Ulrich's International Periodicals Directory published by R.R. Bowker.

Unlimited Power by Anthony Robbins. Published by Fawcett Columbine.

Unstoppable: 45 Powerful Stories Of Perseverance And Triumph From People Just Like You by Cynthia Kersey. Published by Sourcebooks, Inc.

A Visual Artists Guide to Estate Planning published by the Marie Walsh Sharpe Foundation and the Judith Rothschild Foundation.

*Wage Slave No More!: Law And Taxes For The
Self-Employed* by Stephen Fishman. Published by
Nolo Press.

*Working Mothers 101: How To Organize Your Life,
Your Children, and Your Career To Stop Feeling
Guilty and Start Enjoying It All* by Katherine Wyse
Goldman. Published byHarperCollins.

*Working Smart: How to Accomplish More in Half
the Time* by Michael LeBoeuf. Published by Warner
Brooks, Inc.

*Working Solo: The Real Guide to Freedom and
Financial Success with Your Own Business* by Terri
Lonier. Published by John Wiley & Sons, Inc.

The Zen of Creative Painting by Jeanne Carbonetti.
Published by Watson-Guptil.

PERIODICALS

American Artist
770 Broadway, New York, NY 10036
T: 800-745-8922
W: www.myamericanartist.com

Art + Auction
11 East 36 St., 9th floor, New York, NY 10016
T: 212- 447-9555
W: www.artandauction.com

Artforum
350 Seventh Ave.New York, NY 10001
T: 212-475-4000
W: www.artforum.com

Art in America
575 Broadway, New York, NY 10012
T: 212-941-2806
W: artinamericamagazine.com

*Art in America Guide to Museums, Galleries &
Artists,* published in August by *Art in America.*

ARTnews
LIC, 48 West 38 St., New York, NY 10018
T: 800-284-4625
W: www.artnews.com

Art Now Gallery Guide
97 Grayrock Rd., PO Box 5541, Clinton, NJ 08809
T: 908-638-5255
W: www.galleryguide.org

Art Times
PO Box 730, Mt. Marion, NY 12456
T/F: 845-246-6944
W: www.arttimesjournal.com
E: info@arttimesjournal.com

F.Y.I.
New York Foundation for the Arts
155 Avenue of the Americas, New York, NY 10013
T: 212-366-6900
W: www.nyfa.org

Gallery & Studio
217 East 85 St., PMB, New York, NY 10028.
T: 212-861-6814
E: galleryandstudio@mindspring.com

Manhattan Arts International online magazine
200 East 72 St., New York, NY 10021
T: 212-472-1660
E: info@manhattanarts.com
www.manhattanarts.com/pages/
magazine.html

The New Criterion
P.O. Box 3000, Denville, NJ 07834
For subscriptions call: 800-783-4903
W: www.newcriterion.com

The Photo Review magazine
The Photograph Collector
The Photographic Art Market
The Photo Review Newsletter
Published by The Photograph Collector
140 East Richardson Avenue, Suite 301, Langhorne,
PA 19047. T: 215-891-0214.
E: info@photoreview.org

Sculpture Magazine
Published by the International Sculpture Center
T: 212-785-1144
W: www.sculpture.org

Sculpture Review
Published by the National Sculpture Society
1177 Avenue of the Americas, New York, NY 10036
T: 212-764-5645

GRAPHIC DESIGN

ADS2GO New York Inc.
The Piano Factory, 454 West 46 St., Suite 5ES, New
York, NY 10036. T: 212-333-3357/914-633-6671
E: denapoliart@optonline.net
W: www.ads2gony.com
A full-service advertising agency.

Artigiana Graphic Design/Andrea Gengo
118-21 Queens Blvd., Suite 502, Forest Hills, NY
11375. T: 718-261-1445. E: andrea@agd-studio.com
W: artigianagraphicdesign.com
Specializing in identity packages and sales materials
of any scope.

Art of Gold / Marcy Gold
30 River Ct., Apt 2405, Jersey City, NJ 07310-2110
T: 201-626-5771. E: GOLDBRUSH3@aol.com
W: MARCYGOLD.com
Graphic design services for fine artists. Logos,
business cards, letterheads, brochures.

CAREER GUIDANCE

Art Information Center / Dan Conchlar
55 Mercer St., New York, NY 10012. T: 212-966-
3443. Counseling and direction for artists about
NYC galleries.

ArtIsIn / Susan Kolin Schear
879 Amaryllis Avenue, Oradell, NJ 07649. T: 201-
599-9180. Business development and counseling to
artists and organizations.

Artist Resource Kollectiv
T: 718-745-2366. E: arkinc@nyc.rr.com
Consultants specializing in developing marketing
plans, promotional strategies and presentation tools
for artists, art groups and galleries.

ArtNetwork / Constance Smith
PO Box 1360, Nevada City, CA 95959.
www.artmarketing.com. Publishers of art marketing
books and newsletters, and rents mailing lists.

Frank Bruno
710 Collegeville Rd., Collegeville, PA 19426.
T: 610-489-4213. E: frank-bruno@comcast.net
W: www.artistfrankbruno.com. Art marketing and
career coaching to beginning and emerging artists.

Caroll Michels
19 Springwood Lane, East Hampton, NY 11937.
T: 516-329-9105. Artist career advisor and advocate
and author of *How to Survive & Prosper As An
Artist*. She provides phone and in-person
consultations. She offers mailing lists and
Artist/Gallery Contracts.

Renée Phillips
200 East 72 St., New York, NY 10021.
T: 212-472-1660. E: Renee@ManhattanArts.com
W: www.ManhattanArts.com. Career consultant and
life coach for creative individuals. All career levels,
and media. Private and group sessions.

ARTIST REPRESENTATION

The Gallery Walk / Rosemary Zabal
845 Circle Ave., Franklin Lakes, NJ 07417. T: 201-891-8689. F: 201-891-5639.
E: rzabal@thegallerywalk.com
W: www.thegallerywalk.com
An artist agency, dedicated to representing artists for the purpose of exhibiting and selling their work.

PSYCHOTHERAPY

Sandra Indig, C.S.W., A.T.R.-B.C.
T: 212-330-6787. An artist, arts therapist and analytic psychotherapist. To experience full expression of one's talent is a primary goal.

TAX ASSISTANCE

Tax Club For Artists®
The Empire State Building, 350 Fifth Avenue, Suite 5410, New York, NY 10118. T: 1-877-829-2582.
W: www.taxclubfor artists.com. An artist forum where artists can become educated about the business aspects of their trade. In 2005 it will launch a series of exclusive two-hour workshops designed specifically to help artists incorporate their business and increase tax returns.

COPYRIGHT

Copyright Office.
Register of copyrights. The Library of Congress, Washington, DC 20559. Ask for the free Visual Artists copyright information kit, containing registration forms for fine artists and other information. For forms call: 202-707-9100. For information pertaining to copyright law or procedures call: 202-707-3000.

WEBSITE DESIGN

Stephen Beveridge
T: 212-928-8351. E-mail: sdb@scotstyle.com
Website: www.scotstyle.com Website designer and consultant specializing in artist's websites.

Clearweave Corporation / Colin O'Brien
219 South Main St., Ste. 203, Ann Arbor, MI 48104.
T: 800-886-9545. Email: info@clearweave.com
Websites for artists and small businesses. New (and renewed) sites designed by artists.

SCANS

Mildred Kaye
87 Kern Pl., Saddle Brook, NJ 07663. T: 201-843-7651. E: millyK@artniks.com
W: www.artniks.com/digitalservices
Quality scans, on CD-ROMs, with your image on the CD label. Also, designing and formatting of promotional pieces. 8" x 10" prints of your images.

FINE ART CUSTOM FRAMING

Jadite Galleries / Andres Betancourt
662 10th Ave., New York, NY 10036. T: 212-977-6190. E: JADITEART@aol.com
W: JADITEART.com
Conservation quality picture framing, selected frames and mats, acid free materials, canvas stretching.

Julio Valdez Studio
176 East 106th St., 4th Fl, New York, NY 10029.
T: 212-426-6260. E: silkaquatint@hotmail.com
W: www.latinamericamaster.com
Fine art, archival quality custom framing at affordable prices. Serving artists, galleries and institutions. Fast turnaround.

PRINTERS

Graphic Lab Digital Communications / Chris Campisi
228 East 45 St., New York, NY 10017. T: 212-682-1815. W: www.graphiclabinc.com
Art on canvas; Digital Printing; Large format posters; Custom projects; Drum scanning; Digital C-prints; Digital camera photoprints; and more.

Omega Fine Art
9 Tartan Ct., Andover, NJ 07821. T: 973-448-7000. Toll free: 888-225-2125. E: omega@ warwick.net. Highest quality IRIS Giclée printing for galleries, publishers, artists. Miniature to Grand format on paper and canvas. Archival materials.

Art Editions: T: 800-331-8449.

Brilliant Color Line: T: 800- 869-8398.

Color Card: T: 800-875-1386. www.afullcolorcard.com

Color Q: T: 800-999-1007.

Go Card: T: 212-925-2420.

Great American Printing: T: 800-440-2368.

Mitchell Graphics: T: 800-841-6793.

Modern Postcard: T: 800-959-8365.

Original Card Company: T: 800-587-2640. W: www.originalcards.com

Post Script Press: T: 800-511-2009. W: www.psprint.com

PHOTOGRAPHY SERVICES

Delilah McKavish
Photographer: Digital/Film
T: 212-675-1235 or 917-318-5001
E: dmckavish@earthlink.net

Experienced corporate photographer: Public relations, executive portraits, head shots, art work, architectural, industrial. Digital/film assignments delivered within three business days.

Photographics Unlimited
17 West 17 St., New York, NY 10011
T: 212-255-9678. Slides and transparencies from two-dimensional artwork, photographed on their premises. Also black and white photography, slide dupes and other custom lab services.

Bob Sasson
T: 212-675-0973. Photography Specialist for beginner and established artists. Impressive results help further your career. Professional quality slides, transparencies, digital, prints.

ART STORAGE

Filebank, Inc.
28 Courtland St., S Paterson, NJ 07503.
T: 800-625-7163 or 973-279-4411.
E:filebankinc @filebankinc.com.
W: www.filebankinc.com
Located 20 minutes outside New York City, Filebank provides highly secure, climate controlled vault storage for art work. They offer an online photographic inventory to their clients

FOUNDRY

New York Artcrave Foundry
Tel/Fax: 646-827-9317. W: www.artcrave.com
They cast originals and will custom produce almost any bronze from a photo or artist's drawing. They do metal alloys-compounds casting, moldmaking, and more.

ARTS ASSOCIATIONS

Awakening Arts Worldwide Artists Network
T: Toll free 1-877-463-7443
W: www.AwakeningArts.com and
www.AwakeningArts.net
It supports uplifting the human spirit and awakening higher consciousness through the arts. Resource Nexus, exhibitions, retreats and symposiums.

Chicago Artists' Coalition
11East Hubbard St., 7th floor, Chicago, IL 60611.
T: 312-670-2060. An artist-run coalition of visual artists and friends that provides educational, advocacy and professional services. It publishes *The Chicago Artists' News.*

Flushing Council on Culture & The Arts
137-35 Northern Blvd., Flushing, NY 11354. T: 718-463-7700. W: www.flushing townhall.org. It makes the arts a central part of life for developing the arts in the community. It presents exhibitions, seminars and offers technical assistance to artists.

National Sculpture Society
237 Park Ave., New York, NY 10017. T: 212-764-5645. F: 212-764-5651. W: www.sculpturereview. com/nss.htm. It promotes excellence in figurative and realist sculpture throughout the US. It sponsors exhibitions, publishes *Sculpture Review,* provides academic scholarships, and operates the National Sculpture Society gallery.

New York Artists Equity Association
498 Broome St., New York, NY 10013. T/F: 212-941-0130. It disseminates information regarding legislation and legal rights, addressing "survival" issues relevant to artists. It monitors local, state and federal legislation and strongly advocates bills in support of art and artists.

New York Foundation For The Arts
155 Ave. of the Americas, New York, NY 10013.
T: 212-366-6900. W: www.nyfa.org. It provides fellowships, residencies, loans, and fiscal sponsorship of organizations. Its Visual Artist Information Hotline can be reached at 800-232-2789. W: www.nyfa.org/vaih and provides information services for artists and organizations.

Public Art Fund
1 East 53 Street, New York, NY 10022. It promotes the use of art in public spaces in New York City and sponsors art installations.

Salute to Women in the Arts
An environment in which male and female visual, literary and performing artists meet their peers, share ideas and experiences, and make career contacts vital to artistic growth. President: Rosemary Zabal: T: 201-891-8689. E: salutewomeninart@hotmail.com. www.SaluteToWomenInTheArts.com

Volunteer Lawyers For The Arts
1 E. 53 Street, New York, NY 10022. T: 212-319-2787. It provides arts-related assistance to low-income artists. Its Art Law Line 212-319-2910 is for artists needing quick answers to arts related legal questions. (Check your local listings for the VLA branch nearest to you.)

Women's Studio Center
Entrance: 21-25 44 Ave., Long Island City, NY 11101. Mailing Address: 43-32 22 St., Long Island City, NY 11101. T: 718-361-5649. E: WSC586 @aol.com. W: www.womenstudiocenter.org Melissa Wolf, Executive Director. A fine art studio and membership organization that offers studio space for visual artists, workshops and events for visual artists and writers. It publishes *Women's Arts News.*

WRITING SERVICES

Ed McCormack

217 East 85 St., PMB 228, New York, NY 10028.
T: 212-861-0683
E: galleryandstudio@mindspring.com
New York writer and critic available for catalogue essays for artists, galleries and museums.

Manhattan Arts International

200 East 72 St., Suite 26-L, New York, NY 10021.
T: 212-472-1660
E: info@ManhattanArts.com
W: www.ManhattanArts.com
Writing and editing of biographies, résumés, artist's statements, press releases and art essays.

ART PROFESSIONALS: To participate in the Manhattan Arts International Network of Artrepreneurs™ please contact Richard Davis, Manhattan Arts International, 200 East 72 Street, Suite 26L, New York, NY 10021.
T: 212-472-1660.
E-mail: RDavis@ManhattanArts.com

MAILING LISTS

All lists are printed with a laser printer on Avery labels.

NEW YORK CITY GALLERIES

Over 1,000 owners and directors of galleries, private dealers, and alternative spaces. This is the most comprehensive, up to date list of its kind. $95

PUBLICITY

Over 325 art editors, writers of regional and national art publications and art critics primarily in the NYC area. Many home addresses of writers and critics are included. Radio and TV media also included. $55

CORPORATE ART BUYERS

Over 300 corporate art buyers primarily, plus 50 leading interior designers and architects in the New York City area. $55
Other states are available. Please inquire.

To order call Manhattan Arts International 212-472-1660
or use the order form on page 139.

INDEX

The Complete Guide To
NEW YORK ART GALLERIES

The Only Comprehensive Resource Of Its Kind

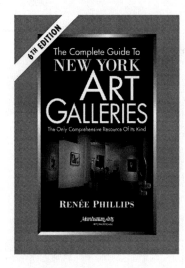

More than 1,000 Detailed Profiles

- Commercial Galleries
- Museums
- Private Dealers
- Non-Profit Venues
- Alternative Spaces
- Cultural Centers
- Corporate Art Buyers
- Artists' Organizations
- NYC Artists' Studios
- NYC Artists' Websites

What You'll Find

- Owner/Director Names • Address • Telephone • Fax • E-mail • Website • Owner's Background
- Year Established • Work Shown • 5 Artists & Description of their Work • Gallery's Focus
- Number of Annual Exhibitions • Advertising Venues • Price Range • Primary Markets • How/When They Select Their Artists • How/When Artists Should Approach Them • What Materials are Required / Response Time • Exhibition fees, if any • More!

Praise for the Book

"The only comprehensive resource of its kind. It is invaluable to any artist seeking to gain access to New York galleries. This book helps artists to better market their work."
Matthew Deleget, New York Foundation for the Arts

"What an accomplishment amassing all the information. I know that others have tried but were unsuccessful." **Caroll Michels, author,** *How to Survive and Prosper as an Artist*

"An invaluable resource for art professionals who are seeking a shoe-in to the art world."
Jill O'Connor, art critic, writer for *Sculpture, Contemporary,* **and** *New York Arts*

To order use the order form on page 139, go to www.ManhattanArts.com or call 212-472-1660.
The book is also sold at Barnes & Noble, Museum of Modern Art, A.I. Friedman, O.K. Harris Works of Art,
Franklin 54 Gallery, and many other fine stores and galleries.

$UCCESS NOW! FOR ARTISTS

"A Motivational Guide For The Artrepreneur"

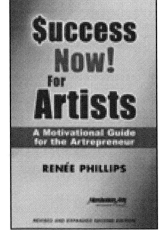

This book contains a generous supply of empowering career strategies, solutions, quick tips and exercises to help you build your career and keep it growing to higher levels.

The author Renée Phillips, "The Artrepreneur Coach™" guides you every step of the way to increase your income, find your buyers, build your market, approach galleries (with specific advice about those in New York), raise the volume on self-promotion, and avoid the common pitfalls artists face that sabotage their careers.

Praise for the Book
"*Success Now!* is a gem of a book and worth its weight in gold for its invaluable information and practical advice for the artist."
Nancy di Benedetto, Art Historian, Author of **History of American Art,**
Lecturer, Metropolitan Museum of Art, Curator, Juror and Consultant

"Renée is all about helping artists become successful. This book makes the business of art more approachable."
Cornelia Seckel, **Art Times Journal**

In this book, working from a deep spiritual base and focused conviction, Renée fuses a plethora of information to address the needs and concerns of the artist."
Sandra Indig, Artist and Psychotherapist

To order use the order form on page 139, go to www.ManhattanArts.com or call 212-472-1660.
The book is also sold at www.Barnes & Noble.com, Museum of Modern Art, and www.Amazon.com.

THE ARTREPRENEUR NEWSLETTER™

- **Artist Career Resources**
- **Juried Exhibition Listings**
- **Unique Opportunities For Artists**
- **Nuts & Bolts Career Advice**
- **Inspiring Essays**
- **Subscribers' Profiles**
- **Books & Other Resources**
- **Quick Tips**

"*Success Now!* eliminates a lot of time fumbling through costly newsletters. It comes packed with the necessities in an easy to read layout."
– Laurie Catalin

"Your newsletter has always been a source of motivation and inspiration to me."
– Juvenal Reis

"*Success Now!* has helped me build a national list of exhibitions for my résumé."
– Georgiana Cray Bart

Published six times a year by

Manhattan Arts
INTERNATIONAL

Editor-in-Chief: Renée Phillips

1 year subscription $30
To order, please use the order form on page 139, call 212-472-1660, or go to www.ManhattanArts.com.

For a free complimentary copy of the current issue please send a self-addressed stamped envelope to The Artrepreneur Newsletter™, Manhattan Arts International, 200 East 72 Street, Suite 26L, New York, NY 10021.

Subscription available to U.S. residents only.

ORDER FORM

Name _____

Address _____

City _____ State_____ Zip_____

Tel: _____ Email: _____

Name as it appears on the credit card: _____

___ MC ___ VISA Card # _____

Expiration date_____

# copies	Item	Cost per copy	Total
_____	The Complete Guide to New York Art Galleries	$28	_____
_____	Success Now! For Artists: A Motivational Guide for The Artrepreneur	$25	_____
_____	Presentation Power Tools For Fine Artists	$25	_____
_____	One-year subscription to The Artrepreneur Newsletter	$30	_____
_____	New York Contemporary Art Gallery Mailing List on labels	$95	_____
_____	Press List Mailing List on labels	$55	_____
_____	Corporate Art Buyers Mailing List on labels	$55	_____
	Add New York State sales tax		_____
		TOTAL	_____

Shipping and handling charges are included.

If paying by U.S. check or money order please make it payable to

Manhattan Arts
INTERNATIONAL

200 East 72 Street, New York, NY 10021. U.S. shipments only. Sorry, no foreign orders.

Tel: 212-472-1660

Email: info@ManhattanArts.com Website: www. ManhattanArts.com

Thank you for your order!

NOTES OR DOODLES

Would you like a Personalized Portfolio Review?

Now that you have read *Presentation Power Tools For Fine Artists* you'll be well on your way to preparing your promotional materials. At some time, however, you may want to have a personalized review of your materials by Renée Phillips, the author of this book, before sending them to galleries, buyers and the press.

Manhattan Arts International has a Network of writers, editors, journalists, critics and art historians who are available to help you produce the best materials possible. We're ready and able to serve you.

INTERNATIONAL

200 East 72 Street, New York, NY 10021. U.S. shipments only. Sorry, no foreign orders.

Tel: 212-472-1660

Email: info@ManhattanArts.com Website: www. ManhattanArts.com

RENÉE PHILLIPS

"Renée Phillips inspires, guides and encourages artists to reach their goals through sound advice on the business of art. Her lectures are standing room only."
Regina Stewart, Artist and Executive Director, New York Artists Equity Association

Public Speaker, Artists' Advocate Career Consultant & Life Coach

She presents seminars and keynote speeches throughout the U.S. on such topics as *How to*:

- Sell Your Art
- Turn Your Passion into Profit
- Break Into New York Art Galleries
- Raise The Volume on Self-Promotion
- Achieve Your Career Goals
- Create Powerful Presentation Materials

Renée has appeared at:

Barnes & Noble
Katonah Museum
Columbia University
New York University
Artists Talk on Art
Women's Studio Center
City College
New York Foundation for the Arts
American Museum of the Moving Image
Queens Council on the Arts
The Learning Annex

International Art Expo New York
Heckscher Museum
Flushing Arts Council
The Salmagundi Club
Chicago Artists Coalition
Salute to Women in the Arts
Marymount Manhattan College
New York Artists Equity Association
American Society of Contemporary Artists
The Educational Alliance
Catharine Lorillard Wolfe

To arrange for Renée Phillips to present a seminar
please contact Michael Jason: 212-472-1660 or
MJ@ManhattanArts.com

For a current schedule of Renée's seminars
please contact Alexandra Shaw at 212-472-1660 or go to
www.ManhattanArts.com

RENÉE PHILLIPS

Renée Phillips is the author of six editions of *The Complete Guide To New York Art Galleries*, the only comprehensive resource of its kind, three editions of *Success Now! For Artists: A Motivational Guide For The Artrepreneur,* and three editions of *Presentation Power Tools For Fine Artist.* She is founder and Editor-in-Chief of *Manhattan Arts International* magazine (1983-2000), now an online magazine at www.ManhattanArts.com. She has been Editor-in-Chief of *The Artrepreneur Newsletter* since 1991.

As a leading inspirational speaker for artists Renée's seminars and keynote speeches have been held at many universities and art venues throughout the U.S. such as International Art Expo NY, Katonah Museum, Heckscher Museum, Columbia University, Barnes & Noble, and the American Museum of the Moving Image. For more than eight years her monthly workshop "How to Sell Your Art" at The Learning Annex in New York, NY has been attracting artists from around the world. As a faculty member of Marymount Manhattan College she conducted gallery and studio tours and presented a series of Artist and Business seminars.

Known as "The Artrepreneur Coach™" Renée inspires and guides her clients to pursue their passions and attain their career, creative and financial goals. As founder and director of Manhattan Arts International, an artist's resource organization, she builds relationships among members of the art community and art enthusiasts. Her website features the work of more than 350 artists at www.ManhattanArts.com.

As an events organizer and artists' advocate Renée organized the only political debate in the history of NYC devoted solely to the arts, which attracted nearly 1,000 spectators and national media coverage. She has been awarded citations from two NYC mayors. *New York Newsday* featured her as a "Community Leader." Articles about her have appeared in *The New York Times, Crain's New York Business, Our Town, Art Times* and *Gallery & Studio.* Renée is currently on the Board of Directors, as Vice-President of Artists Advocacy, of the Women's Studio Center and a member of ArtTable and the International Association of Art Critics.

She has juried and curated numerous multi-media art exhibitions in art and alternative venues including Lincoln Center and First Women's Bank, many of which received national TV and international print coverage. She organized the "*Manhattan Arts* Debate," the only political debate in NYC's history to concentrate solely on the arts.

Renée studied art at the Art Students League in New York, NY. As a professional artist she had many solo and group exhibitions. Although she is no longer a practicing artist her work is in many private and public collections including Merrill Lynch and Chase Manhattan Bank.

For more information go to www.ManhattanArts.com

NOTES OR DOODLES

Website
Background accomplishments
philosophy
Paintings in different subject areas —
light & sky Trees | Plant up close | Still life
& window series
Landscape

Volunteer Lawyers for the Arts |

Names & addresses of buyers — Sarah